D1597802

IMAGES
of America

CLEVELAND
AND ITS STREETCARS

IMAGES
of America

CLEVELAND
AND ITS STREETCARS

James R. Spangler and James A. Toman

ARCADIA

Copyright © 2005 by Cleveland Landmarks Press, Inc.
ISBN 0-7385-3967-8

Published by Arcadia Publishing
Charleston SC, Chicago IL, Portsmouth NH, San Francisco CA

Printed in Great Britain

Library of Congress Catalog Card Number: 2005928561

For all general information contact Arcadia Publishing at:
Telephone 843-853-2070
Fax 843-853-0044
E-mail sales@arcadiapublishing.com
For customer service and orders:
Toll-Free 1-888-313-2665

Visit us on the internet at http://www.arcadiapublishing.com

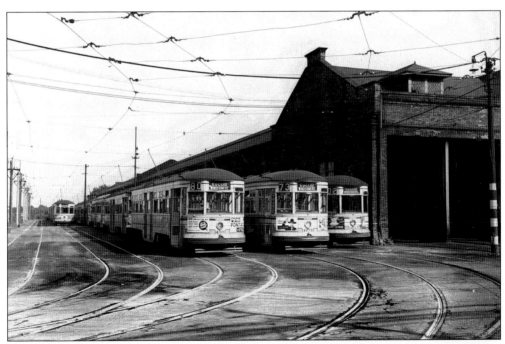

A lineup of streetcars at Windermere Station is ready for the call to service on an August morning in 1951. The cars will operate over the busy Euclid Avenue line. (Herbert H. Harwood Jr., photograph.)

CONTENTS

PREFACE

More than half a century has passed since streetcars could be seen operating along the streets of Cleveland. While the history of streetcars in Cleveland began in 1860, we have decided to emphasize the years 1910 through 1954, the era of the Cleveland Railway Company and the Cleveland Transit System, a period which will resonate more fully in our readers' memories. After a brief look at the earlier period, we have organized the rest of our coverage according to the different areas that the streetcars served.

The challenge we faced was not so much in finding photographs to document the scene, but in selecting the images which appear here from among the many thousands that were taken and saved by the newspapers and the rail-fans of the era. We hope that our selection accurately reflects both the variety and the scope of Cleveland's streetcar days.

Assembling this book was a genuine pleasure, and for that we are grateful to the many individuals who preserved this important part of the city's history by their photography and to those who have helped preserve the photographic record.

We are grateful especially to the following photographers: Roy Bruce, Arnold Bushnell, Bill Cook, Perry Cragg, Bob Crocker, McKinley Crowley, John Gaydos, Herb Harwood, Bill Heller, Al Kleinsmith, Tony Krisak, C. Ness, Bernie Polinak, Doc Rollins, Robert Runyon, Al Schade, and Bill Vigrass. We are also grateful to Blaine Hays, Jay Himes, Rich Krisak, M.D. McCarter, Dave Schafer, Cliff Scholes, and Bruce Young for their work in collecting and maintaining the photographic record of the era. We have attempted to correctly credit each illustration, but many photographs and negatives have changed hands many times. As a result, the source of some of the originals may have been lost with the passage of time. We apologize for any incorrect identification.

INTRODUCTION

The city of Cleveland, Ohio, had its humble beginnings on July 22, 1796. On that date a Connecticut Land Company surveying crew, exploring the acreage it had purchased in the state of Connecticut's Western Reserve, set up camp just south of where the Cuyahoga River emptied into Lake Erie. The group's leader, Gen. Moses Cleaveland, soon returned home, but most of the company remained, and they gave their settlement their leader's name (minus the "a"). The crew thought their settlement's location was ideal. They surveyed the land and devised a system of streets and property parcels radiating from a central commons area, Public Square. The square became the heart of the settlement, and so it has remained.

The initial promise of the location, however, was slow to blossom. Swampy land surrounding the river was a breeding ground for disease, and only the heartiest of settlers were willing to risk their futures under such a cloud. By 1825, the village had only 500 residents, but that was soon to change.

In that year, the State of Ohio authorized construction of a canal that would connect Cleveland to Portsmouth, Ohio, on the Ohio River. The first stretch of this Ohio and Erie Canal opened in 1827, and the entire canal was completed in 1836. The canal not only provided an excellent commercial connection to the hinterland, but it also resulted in draining swamp lands at the mouth of the Cuyahoga River. Cleveland began to flourish. By 1836, its population had jumped to 6,000, and it was granted a city charter.

Cleveland gained another transportation link in 1853 when railroad connections to both New York City and Chicago were established. Cleveland's industrial and commercial growth accelerated, and so did its population. This growth had the expected geographical consequences. Residential and commercial development spread ever farther from the city center. A reliable means of local public transportation became a necessity. The street railway, horse-drawn carriages operating on steel rails built into the streets, seemed to be the solution.

Led by Henry S. Stevens, two companies applied to the City of Cleveland for franchises to operate street railways. The East Cleveland Street Railway received permission to operate over a Euclid-Prospect-Superior route from East 55th Street (then Willson Avenue) to Public Square. The Kinsman Street Railway was authorized to serve those same destination points via a Woodland Avenue route. Both began service in 1860. The success of these first companies soon resulted in nine different horsecar companies operating within the city.

The horse-drawn street-railway era was relatively brief. In Richmond, Virginia, in 1888, Frank Sprague demonstrated that electric power could be used to successfully and economically operate street railways. On December 18, 1888, Cleveland saw its first horsecar line converted to electric

operation. Further economies of operation resulted as formerly competing railway companies merged their operations.

By 1903, almost all of the lines came under the Cleveland Electric Railway Company umbrella. The lone exception was the Municipal Traction Company, supported by Cleveland Mayor Tom L. Johnson, which offered passengers a 3¢ fare.

The two sides then engaged in a prolonged "traction war" for control of the city's transit operations. The cut-throat competition that followed ended with the lines being forced into receivership. Judge Robert W. Tayler eventually worked out a solution to the conflict, which was then approved by city voters. The Cleveland Electric Railway Company became the Cleveland Railway Company (CRC) and was granted a 25-year franchise to operate the system. Its control became effective on March 2, 1910.

The Cleveland Railway Company era was the streetcar heyday in Cleveland. In 1910, Cleveland's population stood at 560,663. It was the sixth largest city in the United States. That year Cleveland Railway collected 228,607,813 fares. Just about everybody got around town on the streetcars. The company built new operating stations, replaced obsolete streetcars with new ones (almost all built by the G. C. Kuhlman Company of Cleveland), and extended the lines. In 1920, 450,925,677 passengers rode in 1,517 motor and trailer cars over 302 miles of track on 34 streetcar lines.

The company ordered its first buses in 1925. Buses were then viewed as suitable only for areas which could not justify the expense of new streetcar track installation. In 1925, no one thought that buses could ever replace the streetcar as the backbone of an urban transportation system. It was not until 1929 that the first streetcar line, Scranton Road, was converted to bus operation, and that came about only because of major construction along its right-of-way.

In 1935, the original 25-year term of Cleveland Railway's franchise expired, and the City of Cleveland was only willing to renew it on a yearly basis. Public sentiment had begun to favor municipal ownership and operation. After several years of dickering, a price was agreed to, and the Cleveland Transit System (CTS) purchased the assets of Cleveland Railway Company.

CTS took over the system on April 28, 1942. At that time it was operating 23 major streetcar lines, but it was determined to modernize the system. World War II, however, increased public dependence on public transit, and war-time industrial restrictions meant that major changes would have to wait until the war was over.

In 1944, CTS produced its first modernization plan. It called for retaining 17 streetcar lines, equipping them with modern President's Conference Committee (PCC) streetcars, and re-routing them over private rights of way on the portions of their routes nearest downtown. CTS bought 75 of the modern streetcars in 1946. Then came a change in plans. Consultants convinced the transit board to scrap all streetcar lines and instead build a single east-west rapid transit line with a downtown loop subway. The new plan received transit board and city approval in May 1946. These decisions signaled the end of streetcars in Cleveland.

The Scovill streetcar line was the first post-war conversion. It was changed to buses. Next came the Cedar line. It was replaced by trackless trolleys. Each subsequent year, more lines were modernized, 11 of them to the trackless trolley mode. Finally, only one streetcar line remained, the Madison Avenue line from Public Square to Spring Garden Avenue in Lakewood. Its last day came on Sunday, January 24, 1954. Despite the frigid temperatures, about 10,000 Clevelanders stood in line for hours to take a free final ride. The end had come to 94 years of streetcars in Cleveland.

One

EARLY STREETCARS IN CLEVELAND

When the Cleveland Railway Company took over operation of the city's streetcar lines in 1910, it inherited a fleet of streetcars from three predecessor companies, Cleveland Electric Railway Company, Cleveland City Railway Company, and Municipal Traction Company. Many of these companies' fleets had once belonged to earlier companies. Cleveland Railway inherited a streetcar fleet of 1,298 units from six different manufacturers as well as some built by the operating companies. Some of these cars were retired soon after consolidation, but others, especially those which operated in shuttle (dinkey) service, survived in passenger service until 1939. Cleveland Railway ordered its first fleet of 25 cars in 1910 from the Cleveland-based G. C. Kuhlman Car Company. Major replacement of the inherited cars, however, did not take place until Cleveland Railway received its large order for 201 center-entrance cars from Kuhlman in 1913 through 1914. Some of the early passenger cars were later converted into work cars which saved them from early scrapping.

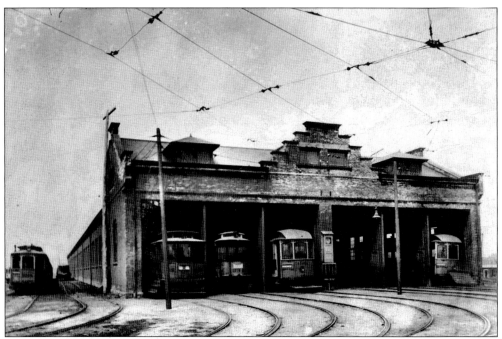

The Windermere Car House in East Cleveland was built by the Cleveland Electric Railway Company in 1907. It served the system's Euclid Avenue car line, its busiest. After streetcar service on Euclid Avenue was abandoned in 1952, the car barn was raised to make way for the new Windermere station at the easternmost end of the city's rapid transit line. (Al Schade collection.)

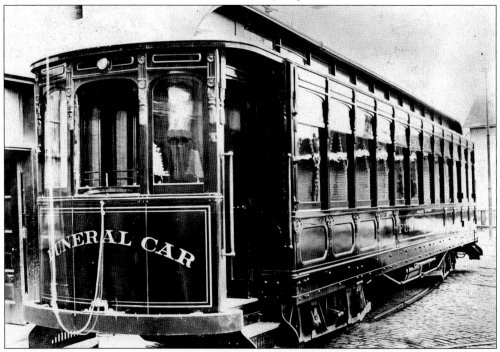

The streetcar served a variety of human needs. Cleveland had two funeral cars that would carry the deceased and the bereaved to various cemeteries on both sides of the city. (Jim Toman collection.)

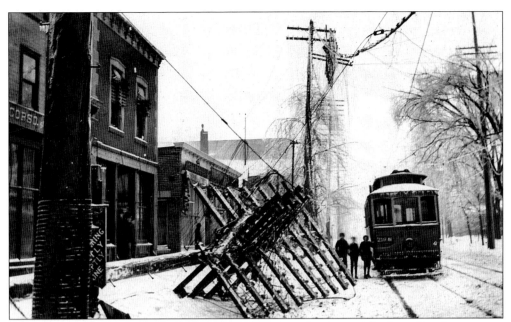

While electrically operated streetcars represented a major advance over the days when the cars were pulled by teams of horses, they still could face adversity. Here, car 448 is stalled by a loss of power when a pole collapsed under the weight of a 1913 winter sleet storm. (Jim Spangler collection.)

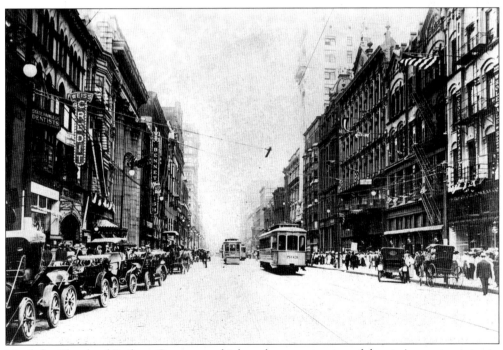

Until the Cleveland Railway Company, which took over operation of the city's transit service in 1910, could modernize its streetcar fleet, it had to make do with the equipment it inherited from its predecessors. Here pre-consolidation cars meet on lower Euclid Avenue near East 4th Street in 1911. (Bruce Young collection.)

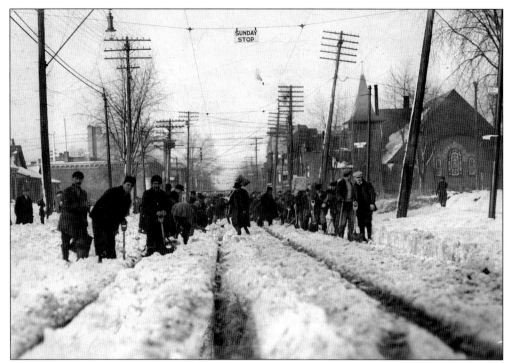

Winter weather posed traffic problems long before most people did their commuting by automobile. Here, following a major blizzard in 1913, a Cleveland Railway work crew struggles to clear the tracks at East 105th Street and St. Clair Avenue. (*Cleveland Press* photograph, Jim Spangler collection.)

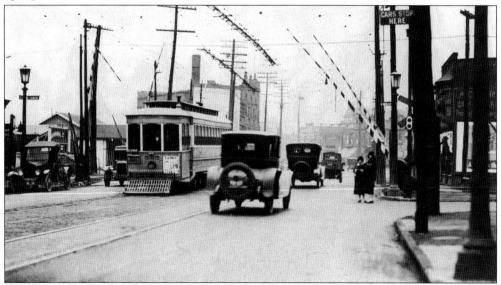

A streetcar passes over the Nickel Plate Railroad crossing at Buckeye Avenue and East 86th Street. The guard above the overhead wire helped ensure that the trolley pole would not get dislodged and leave a streetcar without power at a railroad crossing. The railroad tracks were later bridged over. Today the east side rapid transit line runs parallel to the railroad track. (Al Schade collection.)

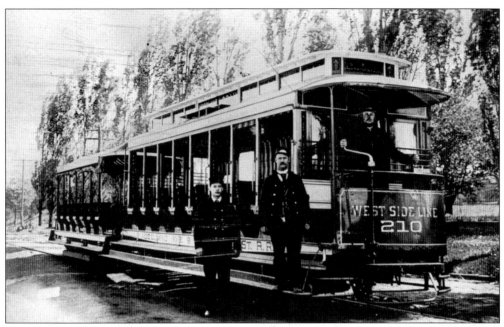

Woodland and West side Street Railway open car 210 pauses at the end of the Woodland Avenue line at East 84th Street, adjacent to St. Joseph Cemetery. (Jim Spangler collection.)

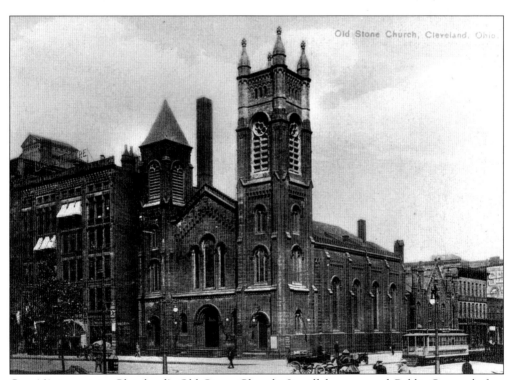

Car 461 is next to Cleveland's Old Stone Church. It will loop around Public Square before returning to St. Clair Avenue. The building to the left of the church was the home of the Lyceum Theater. (Jim Spangler collection.)

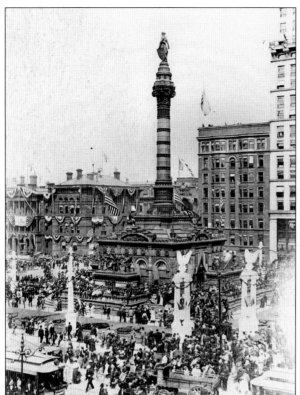

Two streetcars edge through a crowded Public Square, which is hosting the 35th encampment of the GAR. The date is September 5, 1901. The monument at the center of the scene is the Soldiers and Sailors monument, built in memory of Clevelanders who served during the Civil War. (Bruce Young collection.)

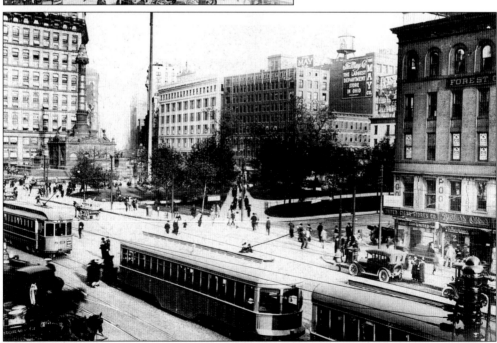

Three pre-consolidation streetcars head east through Public Square in 1910. At the right of the scene is the Forest City House. That site will later host the Hotel Cleveland. The May Company and Park Building form the center backdrop. (Jim Toman collection.)

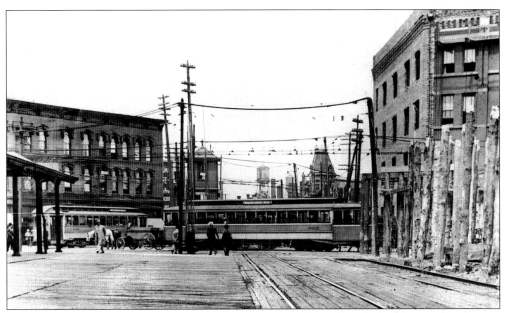

Streetcars in Euclid Avenue and East 55th Street service negotiate the intersection of the two streets and the Pennsylvania Railroad tracks. The scene looks north. This bottleneck was eased in 1915 when the railroad tracks were put onto an elevated structure. A railroad passenger station was also built at this intersection. (Jim Spangler collection.)

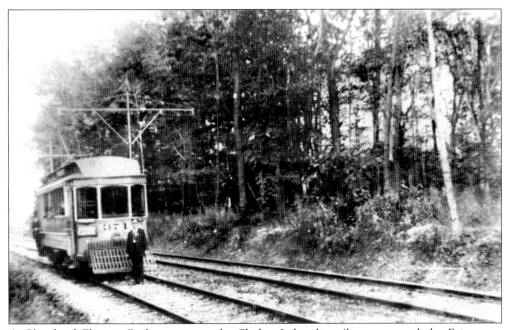

A Cleveland Electric Railway car on the Shaker Lakes line (later renamed the Fairmount Boulevard line) descends its private right-of-way on Cedar Hill. Streetcar service on the hill opened the suburban heights area to residential development. (Jim Spangler collection.)

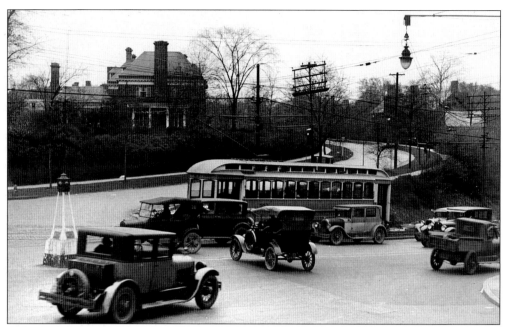

A former Cleveland Electric Railway railroad-roof car reaches the top of Cedar Hill on its way down to Cedar Glen. While the streetcar enjoyed a private right-of-way, automobiles had to jockey for position. (Jim Spangler collection.)

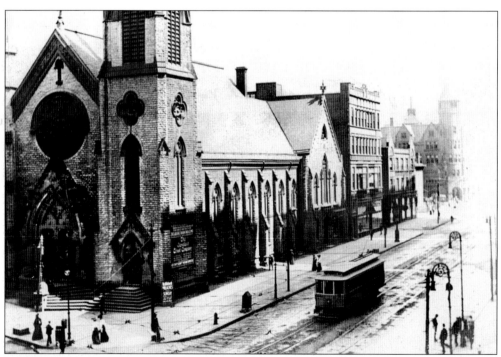

In 1907, a streetcar on East 9th Street pauses at Euclid Avenue. The First Methodist Church would soon be razed to make way for the headquarters of the Cleveland Trust Company bank rotunda. The church relocated to Euclid Avenue and East 30th Street. (Bruce Young collection.)

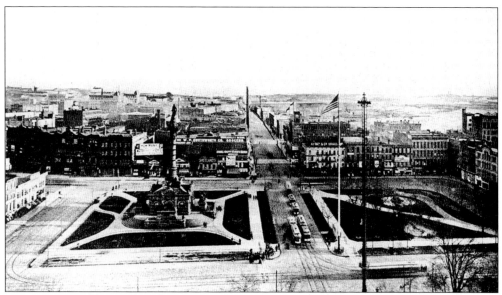

In 1895, the Soldier and Sailors Monument dominates Public Square. The streetcars are on Ontario Street. The scene looks south. The major changes in the Public Square area were still years away. (Bruce Young collection.)

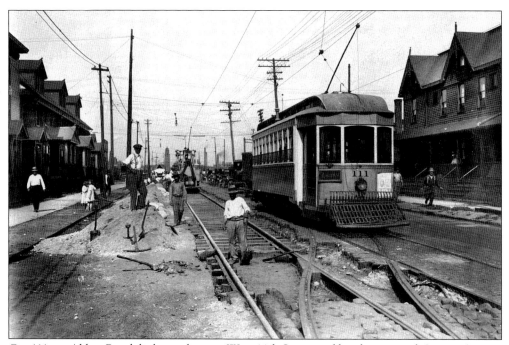

Car 111, an Abbey Road dinkey, is leaving West 14th Street and heading towards Lorain Avenue and the West Side Market. Workers are rebuilding the eastbound track. (Doc Rollins photograph, Bruce Young collection.)

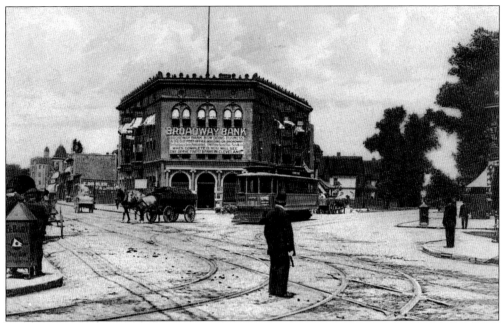

Car 459, in East 55th Street service, is about to cross Broadway Avenue on its way to the Slavic Village area of the city. The Broadway Bank building is to the left. The car was sold to Michigan Railways in 1918. (Jim Spangler collection.)

Cleveland Railway 867 is on the East 79th Street private right-of-way at Addison Avenue. East 79th Street did not become a through street for automobiles until streetcar service on the street was abandoned in 1940. (Jim Spangler collection.)

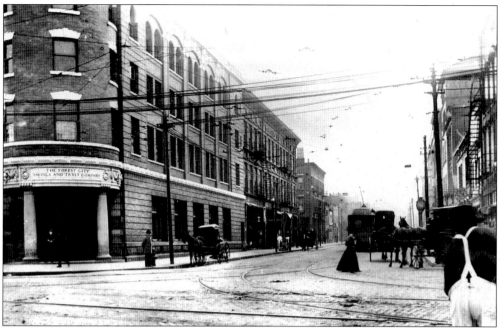

The tracks at Detroit Avenue and West 25th Street date this scene. They lead streetcars to the old Superior Viaduct for a trip to downtown Cleveland. All this changed in 1917 when the Detroit-Superior High Level Bridge was completed and streetcars traveled across it on a lower deck subway. (Cleveland Picture collection of the Cleveland Public Library.)

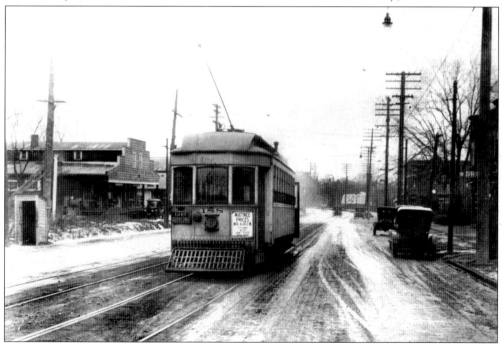

A Euclid Village dinkey is approaching East 212th Street. The dinkey operated between Windermere and East 212th Street until the Euclid Avenue line was extended in 1929. There were 12 such dinkey services in the system. (Al Schade collection.)

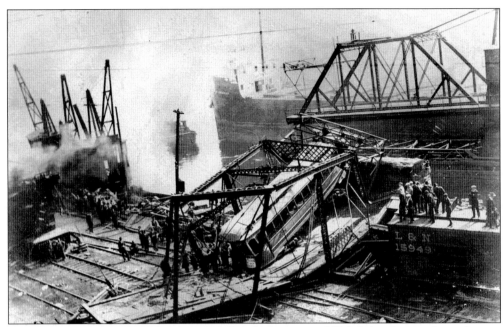

Tragedy struck the system in October 1916 when brakes on car 387 failed and it struck another car on the Scranton Road Bridge. The collision caused the bridge to collapse. Streetcars in Scranton service had to be rerouted via West 25th Street and Clark Avenue. (Bruce Young collection.)

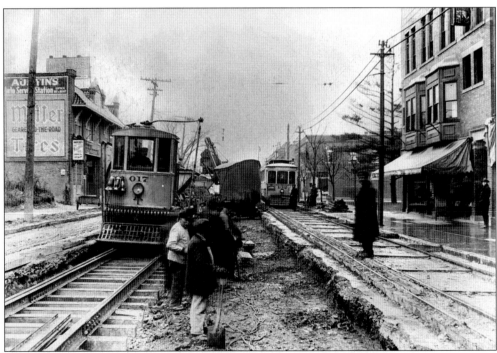

A Detroit Avenue streetcar is outbound in Lakewood, Ohio. In this view, the line has been single-tracked to allow a new outbound track to be installed. (Bruce Young collection.)

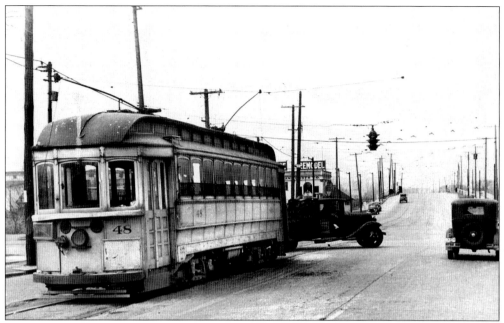

The State Road dinkey, which ran between Brookpark Road and Ridgewood Drive, was the last short-line survivor. The dinkey continued in service until April 1939. Cleveland Railway 48, a 1902 product of the G. C. Kuhlman Car Company, rests at Brookpark Road. The tracks in the background were part of the regular State Road line to downtown Cleveland. (Jim Spangler collection.)

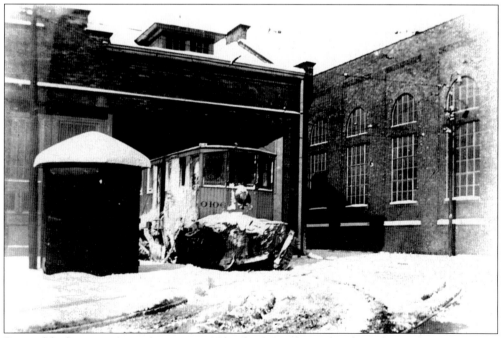

Some of the longest surviving streetcars in Cleveland were from its work-car fleet. Here a 1902-model snow sweeper awaits the call to action on a snowy Cleveland day. The sweeper operated out of Windermere Station. (Bill Cook photograph.)

Four city cars and a Cleveland and Southwestern interurban car (on the left) pause in Public Square. The Williamson Building (built in 1896, demolished in 1984) is in the background. (Dave Schafer collection.)

Two

DOWNTOWN CLEVELAND

Cleveland's west side meets the east side at Public Square, the 8.78-acre common ground at the city center. At the heart of the downtown district, Public Square has been Cleveland's public meeting ground, the place where the city has commemorated its heroes, celebrated its triumphs, and marked its history. Divided into four quadrants, the square was also the place where most of the city's east-west streetcar lines had their downtown terminus. Nine west side lines ended in the square, Clifton, Detroit, and Fulton looping around the northwest quadrant; Madison, Lorain, Clark, and the three West 25th Street lines (Pearl, State, and Broadview) looping around the southwest quadrant. Six east side lines also made their way to Public Square. The St. Clair, Superior, and Payne lines looped around the northeast quadrant, while Euclid, Mayfield, and Fairmount looped around the southeast quadrant. For a time, even the Shaker Heights Rapid Transit and the Lake Shore Electric Interurban lines had their downtown terminus in Public Square.

The streetcar lines serving the southeastern part of the city did not use the Square as their downtown destination. These lines, Central, Cedar, Scovill, Woodland, Buckeye, Kinsman, Union, and Broadway looped via Prospect Avenue and East 2nd and East 4th Streets. Two other lines were entirely downtown operations, the East 9th Street/Pier line and the Union Depot line.

During the 44 years (1910 through 1954) of streetcar service by the Cleveland Railway Company and the Cleveland Transit System, downtown Cleveland echoed with the electric cars' rumble and the squeal of their wheels. The sounds, coupled with their frequent service intervals, made streetcars seem a fixed part of the downtown landscape.

In 1924, a 400-series car on Prospect Avenue pauses at East 9th Street. The flatiron-shaped building to the left is the Osborn Medical Building (now apartments). Hotel Winton, later called the Hotel Carter and more recently the Carter Arms Apartments, can be seen mid-distant on the right. (Bruce Young collection.)

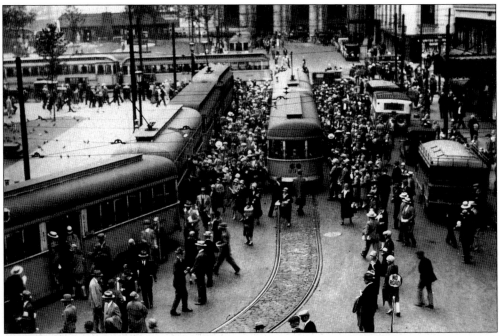

In 1926, the northwest quadrant of Public Square is jammed with people waiting to board streetcars to the west side. The southwest quadrant is where streetcars in Clifton, Detroit, and Fulton service made their downtown loop. (Jim Spangler collection.)

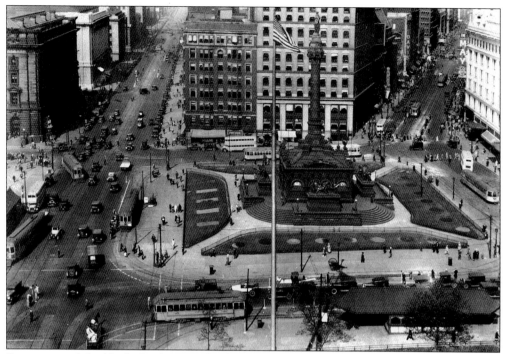

Streetcars and double-decker buses make their way around Public Square in 1926. The Soldiers and Sailors Monument is at the center of the scene, the Cuyahoga and Williamson Buildings are just beyond it. (Cleveland Railway photograph, Jim Toman collection.)

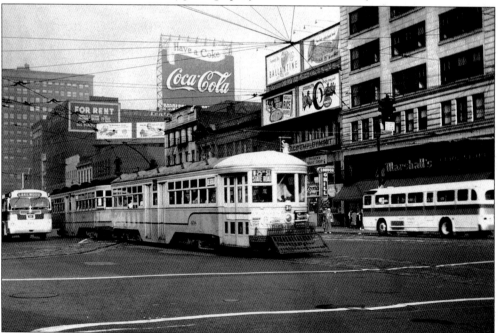

On Cleveland's busiest streetcar routes, motor cars often towed non-motorized trailer cars. Car 408, with trailer 2350 in tow is on Superior Avenue at Public Square. The Marshall Building (demolished in 1989) is at the right. (Cliff Scholes collection.)

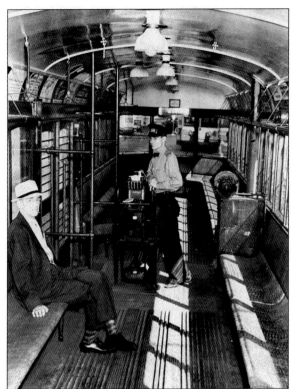

Cleveland Railway had nearly 500 trailer cars in its fleet. The cars were designed to haul as many passengers as possible, rider comfort not being a primary consideration. A conductor was stationed at the center door to collect fares. (Jim Spangler collection.)

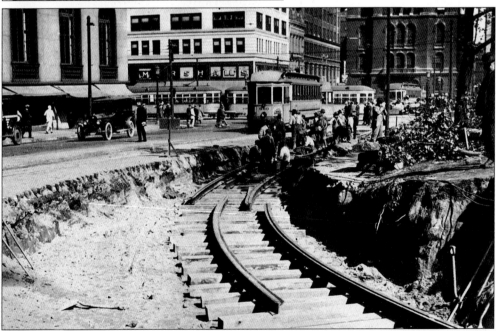

As the Terminal Tower was being built, the city fathers also decided to reconfigure the square, lower it, and change the streetcar pattern to clockwise. In 1928, the project is underway. New track is being laid around the southwest quadrant, but car 660 is still following the original counter-clockwise pattern. (Jim Spangler collection.)

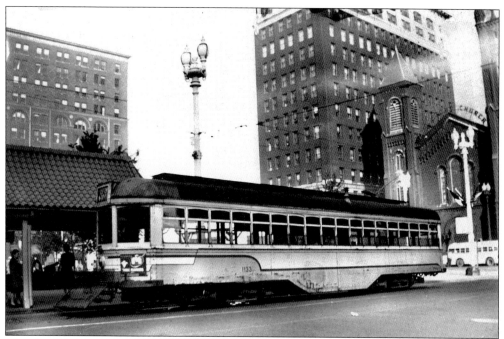

Cleveland Transit System (CTS) 1133 in Clifton Boulevard service pauses at the pagoda in the northwest Public Square loop. Old Stone Church is to the right, the 75 Public Square Building is to the church's left. The streetcar was one of 201 streetcars Cleveland Railway bought from the G. C. Kuhlman Car Company from 1913 through 1914. (Bill Cook photograph.)

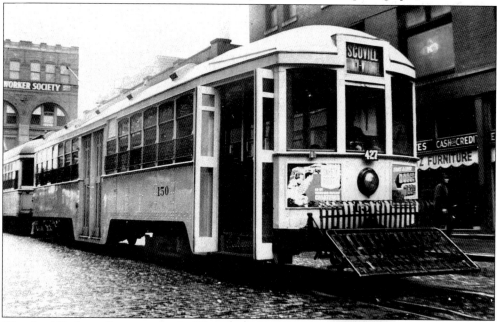

Cleveland Railway Company–built 150 is on East 4th Street at Prospect Avenue. The Scovill streetcar line was one of the southeastern routes which did not use Public Square as its downtown terminus. The Gospel Worker Society Building is in the background, and the Kurtz Furniture Company is to the right. (Harry Christiansen photograph, Jim Toman collection.)

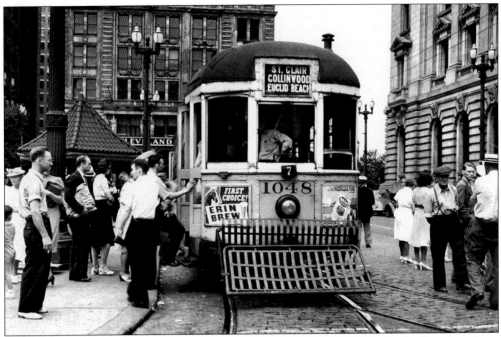

In the summer of 1940, America was not yet at war, and many young people thought taking the streetcar to Euclid Beach Park was a perfect way to spend a summer day. Here St. Clair Avenue car 1048, a 1913 G. C. Kuhlman Car Company product, is boarding in Public Square. The federal courthouse is to the right, and Cleveland College is behind the car. (*Cleveland Press* photograph, Jim Spangler collection.)

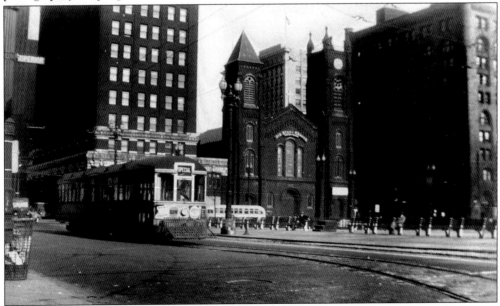

CTS car 1351, marked "Special," is on the northwest quadrant loop of Public Square. The 1300-series cars (1301 through 1376) were built by Cleveland Railway Company crews. Fabricated in the company's Harvard Shops in 1925, the cars cost $10,417 each. They were dependable cars, most of the fleet continuing in service until 1951. (Bill Cook photograph.)

Not every feature of the 1300-series cars guaranteed rider comfort. The old coal stoves could roast passengers seated near them, while leaving riders at the rear of the car shivering with cold. It was the job of the conductor, in this case of the conductorette, to tend to the stove. (Jim Spangler collection.)

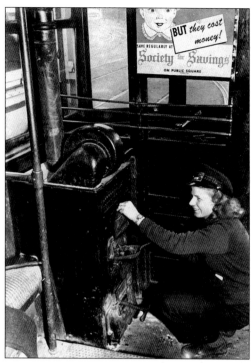

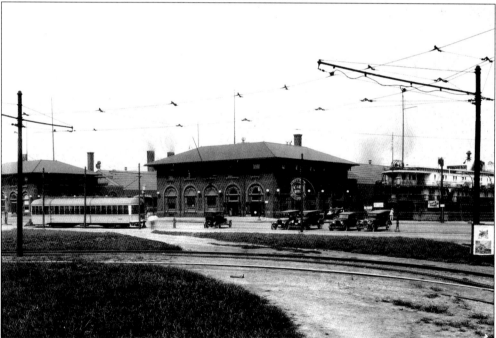

A streetcar is leaving the two-track loop on the East 9th Street line. This short downtown streetcar route was kept busy during the summer months when many Clevelanders enjoyed a Lake Erie cruise ship outing. Lake steamships connected Cleveland with Detroit and Buffalo. The Lake Terminal Building is now the site of the Rock and Roll Hall of Fame. (Blaine Hays collection.)

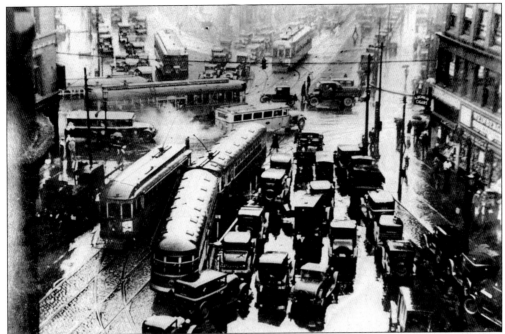

Streetcars, buses, and automobiles crowd the intersection of Prospect Avenue, East 9th Street, and Huron Road in this *c.* 1930 scene. An interurban car can be seen approaching the intersection from Huron Road. (Jim Spangler collection.)

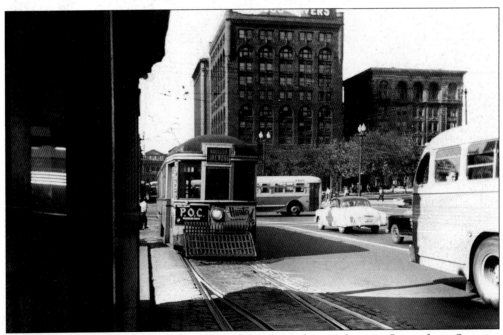

CTS 1323, in Madison Avenue service, has just turned onto Ontario Street from Superior Avenue. It will continue around the southwest quadrant of Public Square before it heads outbound once again to Spring Garden Avenue in Lakewood. The scene is from the summer of 1950. (Roy Bruce photograph.)

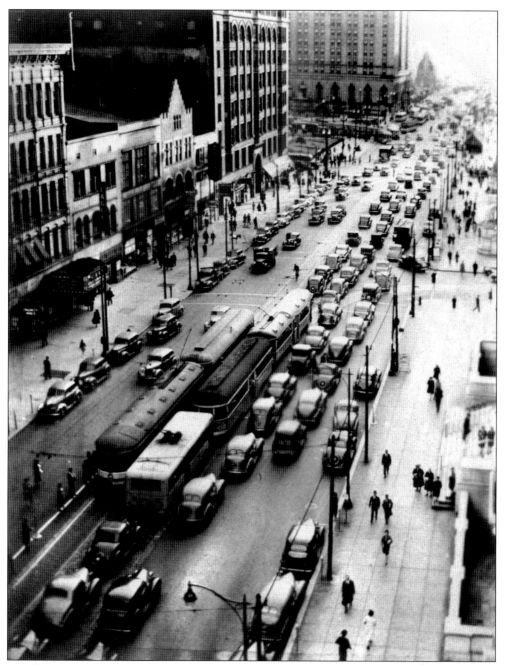

Before World War II began and imposed restrictions on gasoline, increasing traffic was providing mounting evidence of the future dominance of the automobile over public transit. This scene is of Superior Avenue, looking west towards Public Square. (*Cleveland Press* photograph, Jim Spangler collection.)

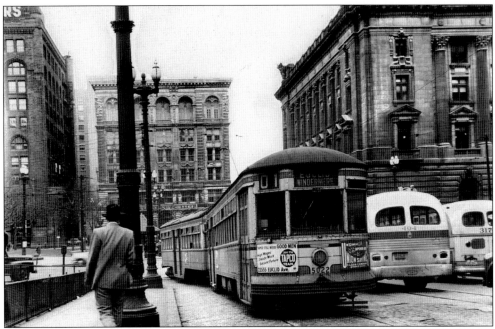

Euclid Avenue was Cleveland's busiest streetcar line. To serve its heavy patronage, Cleveland Railway ordered a fleet of 27 articulated-cars from the G. C. Kuhlman Car Company. Numbered in the 5000 series, the cars could seat 100 passengers. Here car 5022 is completing its Public Square loop and about to turn onto Euclid Avenue for the trip out to Windermere. (Jim Spangler photograph.)

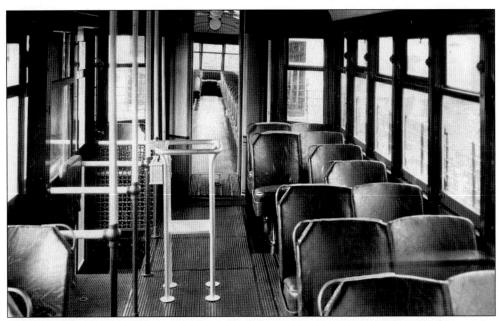

This interior view of a 5000 streetcar shows the first conductor's station and the articulation joint just beyond. A second conductor's station can be seen in the second passenger compartment. Youngsters loved to ride in the articulation joint, which rotated as the car made turns. (*Cleveland Press* photograph, Jim Toman collection.)

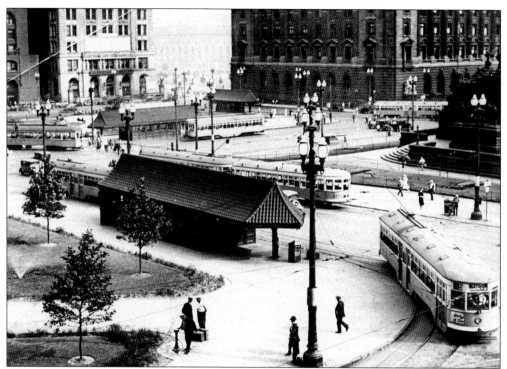

Streetcar waiting stations on Public Square were popularly known as pagodas because of their Oriental styling. Altogether there were five pagodas on the square. They were removed in 1955 when the city administration decided to give the square a more modern look. (*Cleveland Press* photograph, Jim Toman collection.)

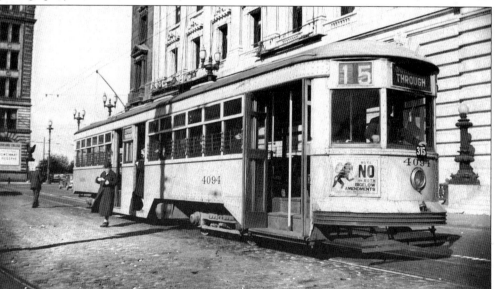

In 1938, Cleveland Railway 4094 is at its terminus on the northeastern quadrant of Public Square. The company purchased 150 of the 4000 series of streetcars from the G. C. Kuhlman Car Company from 1928 through 1930. The 4000s were the last fleet of streetcars bought by Cleveland Railway. (Bob Crocker photography, Cliff Scholes collection.)

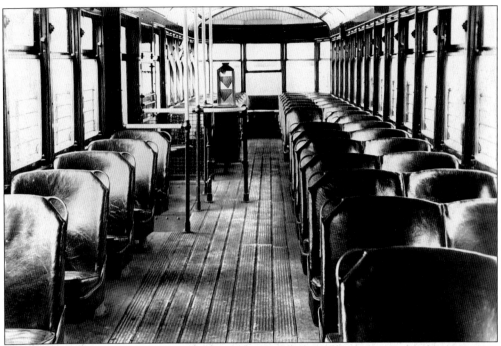

Compared with the earlier streetcars, the 4000s provided a more comfortable ride. Their electric heating and leather seats were welcomed by Clevelanders who had learned to brave more spartan conditions in earlier model motor and trailer cars, but not necessarily enjoy them. (Cleveland Railway Company photograph, Jim Spangler collection.)

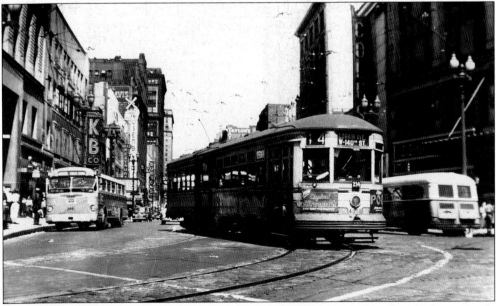

Between 1943 and 1949, the east side Mayfield Avenue line was combined with the west side Lorain Avenue service. In 1949, a Mayfield car is entering Public Square. Instead of looping around the southeast quadrant as Euclid streetcars did, it will continue across Ontario Street to the southwest quadrant before its trip to the west side. (Bill Cook photograph.)

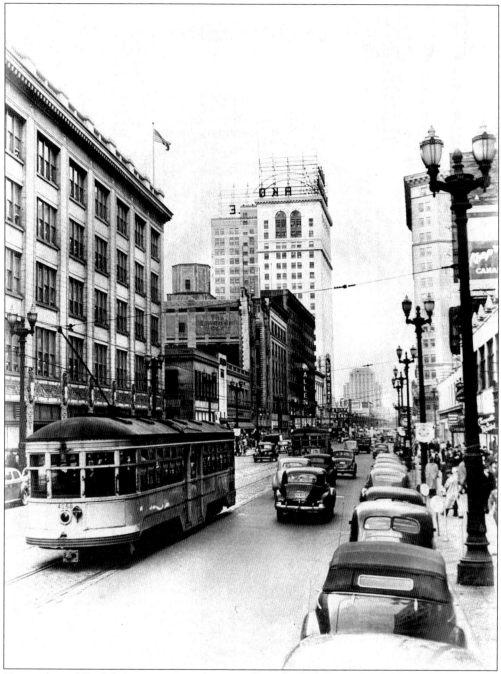

Two outbound Euclid Avenue cars are passing through Playhouse Square in 1946. Six theaters made up the district, and it was a busy stop for the streetcars. (Perry Cragg photograph, Jim Spangler collection.)

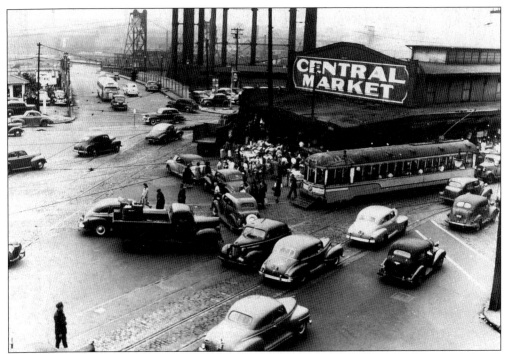

In 1944, a 100-series car in Union Avenue service eases its way through the crowded and complicated East 4th-Ontario-Eagle-Woodland intersection. The Central Market rivaled the West side Market as the city's favorite. The market burned to the ground in December 1949. (Jim Spangler collection.)

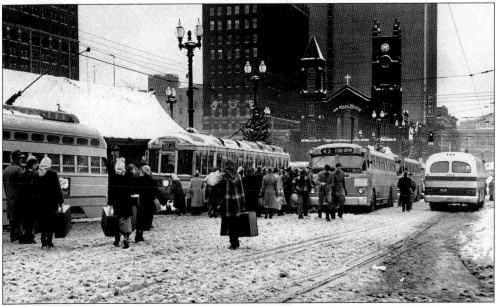

Cleveland winters can be challenging. The Thanksgiving Day snowstorm of 1950 tested the city's snow-removal crews and made shambles of on-time transit performance. Five days after the blizzard, snow and slush on Ontario Street made footing difficult as the post-holiday work week began. (*Cleveland Press* photograph, Jim Spangler collection.)

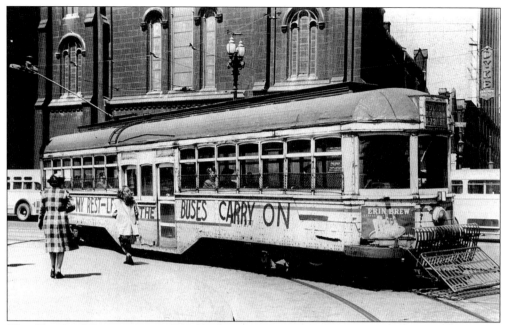

The Cleveland Transit System liked to boast about its modernization efforts. Here, in April 1948, a 1914-model streetcar in Fulton Road service bears a message notifying passengers that buses will soon take over the route. The streetcar is passing in front of the Old Stone Church on Public Square. (Bruce Young collection.)

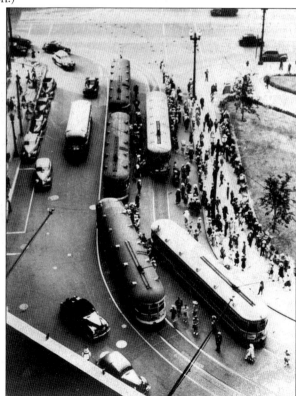

Modern transit-safety regulations were clearly not in force during this 1946 rush-hour scene on the southwest quadrant of Public Square. That year the system achieved its all-time peak in riding, with over 493 million passengers. (*Cleveland Press* photograph, Jim Spangler collection.)

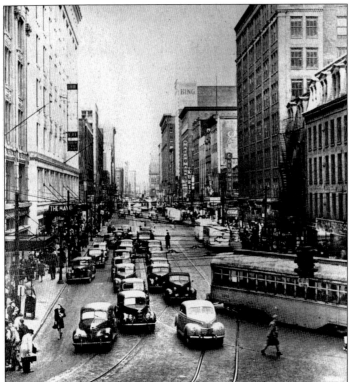

Prospect Avenue was almost as busy a shopping street as Euclid Avenue. This 1946 scene looks east from Ontario Street. The Bailey and May department stores are on the left; Richman Brothers and the Columbia Building are on the right. (Cleveland Transit System photograph, Jim Spangler collection.)

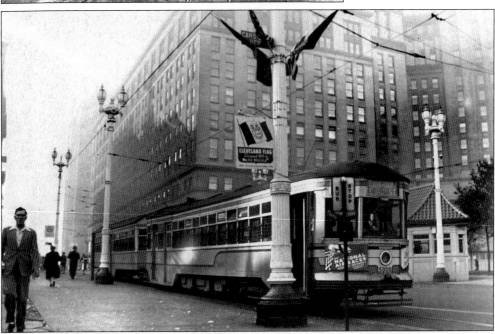

CTS articulated-unit 5000 is on Ontario Street and about to leave Public Square for a trip on the Hayden Avenue branch of the Euclid streetcar line. The sign attached to the light pole helps to date the picture. It is 1946, and Cleveland is celebrating its sesquicentennial as a city. (Jim Spangler collection.)

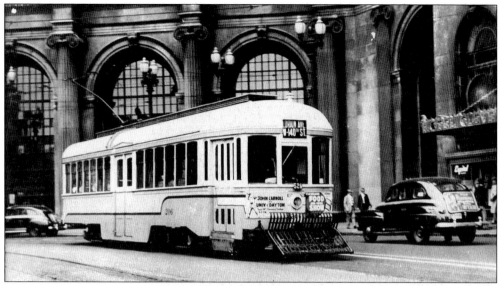

With its new paint job, CTS car 206 looks like new in 1950. The 200-249 series of cars, built by the G. C. Kuhlman Car Company in 1915, represented the first production model of Cleveland's most famous contribution to streetcar service. Formally known as a "Car Rider's Car," the style became known as "Peter Witt" cars after the city's transit commissioner who had recommended the front-entrance, center-exit model as a way to reduce the time it took for passengers to board or leave. The Peter Witt design was copied both nationally and internationally. (J. William Vigrass photograph.)

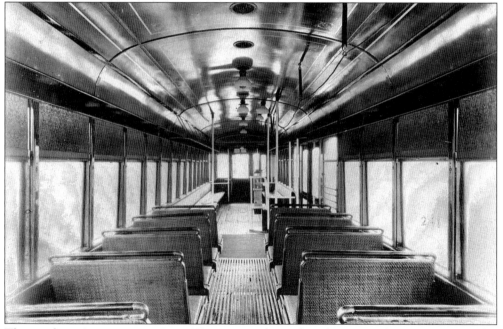

The conductor's station in a Peter Witt car was located at the center doors. Passengers who paid their fares were permitted to move to the rear of the car which featured more comfortable transverse seating. Those who delayed paying their fare until disembarking had to make due with the longitudinal seating that lined the front half of the car. (Jim Spangler collection.)

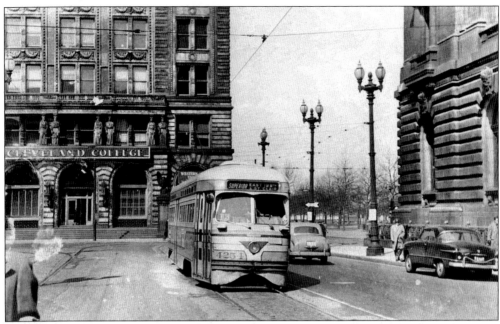

Cleveland's experience with the President's Conference Committee (PCC) streetcar, the latest model in streetcar design, was relatively brief. The Cleveland Transit System bought 75 of the cars in 1946, 50 from the Pullman Standard Company (4200 to 4249) and 25 from the St. Louis Car Company (4250 to 4274). PCC 4251 was one of the city's 25 PCC cars manufactured by the St. Louis Car Company. (Jay Himes collection.)

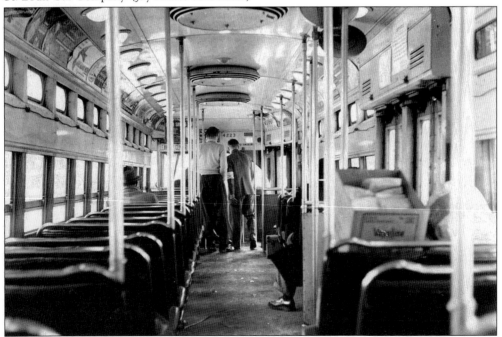

The PCC car interior illustrates some of the advanced features of the car. The overhead ventilators kept the air circulating, the standee windows gave strap-hangers a view of the passing scenery, and the abundance of poles gave standing riders a safer trip. (Jim Spangler photograph.)

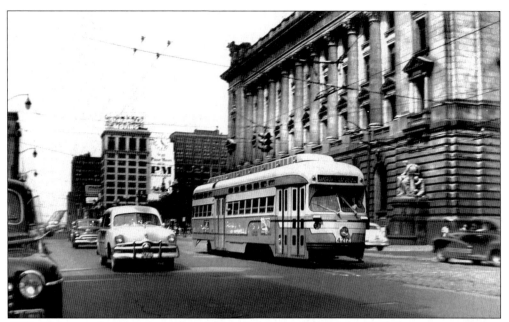

CTS 4212 is on Superior Avenue near East 3rd Street. While the PCC fleet was assigned to several different streetcar lines, the bulk of their service was on the east-side Superior and St. Clair routes. The federal building is in the background to the right. (Bill Cook photograph.)

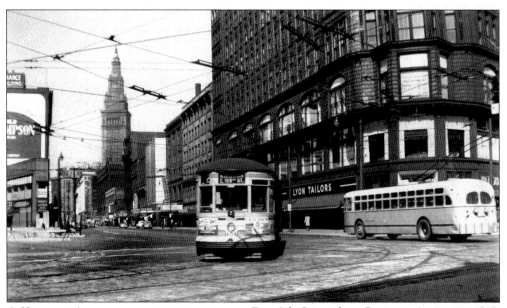

A Kinsman Avenue streetcar is turning onto East 9th Street from Prospect Avenue in 1949. The other streetcar routes that once shared this stretch of track have been converted to trackless trolley operation, many served by Marmon-Herrington coaches like westbound Trackless Trolley 1273. The Rose Building is to the right, and the Terminal Tower can be seen in the distance. (Bill Cook photograph.)

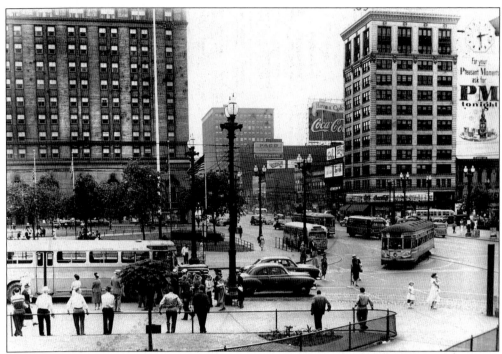

There are more buses than streetcars in this summer 1951 scene. The building to the left is the Hotel Cleveland (now the Renaissance Cleveland). The one to the right is the Marshall Building. (Robert Runyon photograph, Bruce Young collection.)

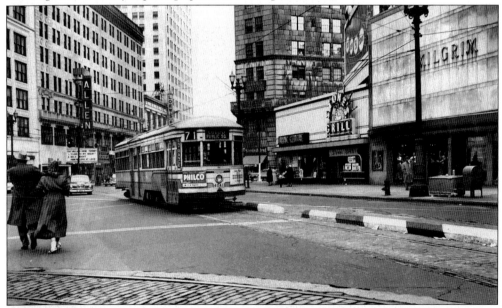

In December 1951, a Euclid Avenue car is detouring onto Huron Road at East 13th Street. Lower Euclid Avenue was often on the city's main parade route, necessitating streetcars to divert via Huron Road to Prospect Avenue before looping back for an eastbound trip. The Allen Theater in Playhouse Square can be seen to the left of the car. (Anthony F. Krisak photograph, Richard Krisak collection.)

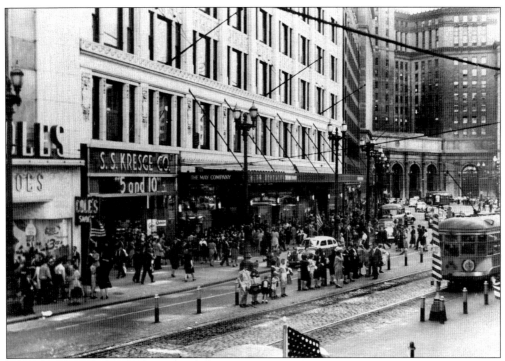

Cleveland's streetcar days were also the heyday of downtown shopping. The white terra-cotta building at the left is the May Company. Farther west, the façade of the Higbee Company peeks into the scene. The Terminal Tower and Hotel Cleveland are in the distance. (Jay Himes collection.)

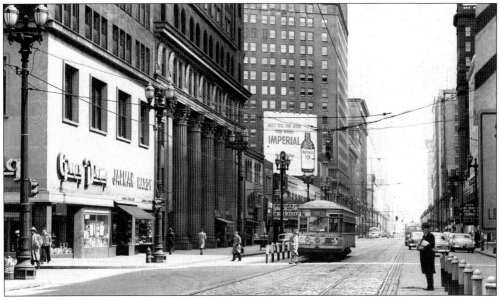

On a quiet Sunday morning in March 1952, a 4000-series car stops on Euclid Avenue at East 6th Street. The columned building is home to National City Bank. The marquee of the Embassy Theater is to its east. The Union Commerce Building (now Huntington Building) looms at the rear center of the scene. (Anthony F. Krisak photograph, Richard Krisak collection.)

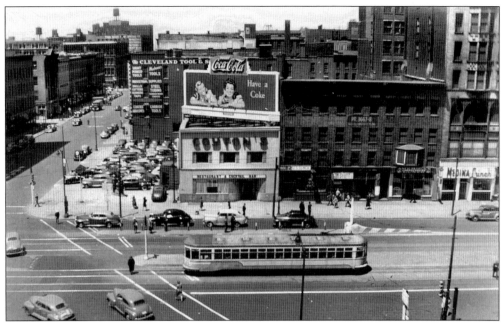

A 4000-series car stops at a passenger island on Superior Avenue at West 6th Street. The stretch of Superior Avenue between West 6th Street and Public Square had four tracks to funnel the streetcars to and from the Detroit-Superior Bridge Subway. (C. Ness photograph, Jim Spangler collection.)

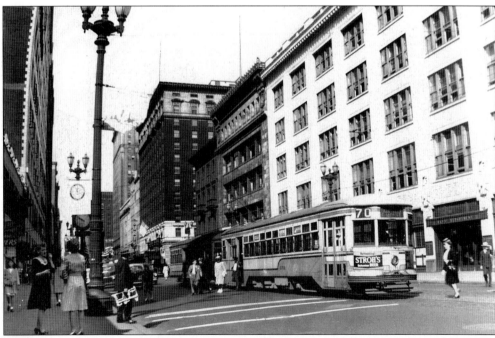

Passengers are disembarking CTS articulated-car 5006 on Euclid Avenue at East 13th Street. The Navy Finance Center is in the building at the right, and just west of it is the old Sterling and Welch store. The two properties became home to the consolidated Sterling, Lindner, Davis store. Farther west is the Union Club and the Hotel Statler. (Bruce Young collection.)

CTS 5010 is on its way out from the downtown area. It has just passed Fenn College (to the right) and is approaching the old Euclid Avenue mansions that once housed the Cleveland Automobile Club and the Cleveland Museum of Natural History. (Robert Runyon photograph, Bruce Young collection.)

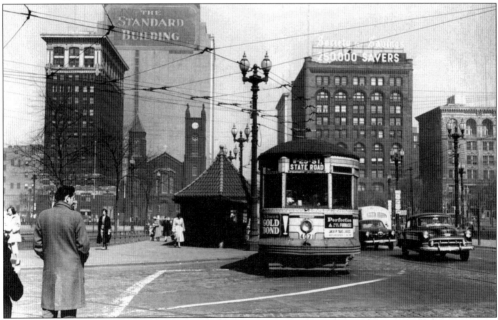

In April 1953, CTS 4071 is making the turn onto the southwest quadrant loop of Public Square. The car is in State Road service, one of only three lines then still being served by streetcars. The Society for Savings Bank Building is in the background. Built in 1890, at the time it was Cleveland's tallest building. Thoroughly renovated in 1990, the building today serves Society's successor, Keybank. (Herbert H. Harwood Jr., photograph.)

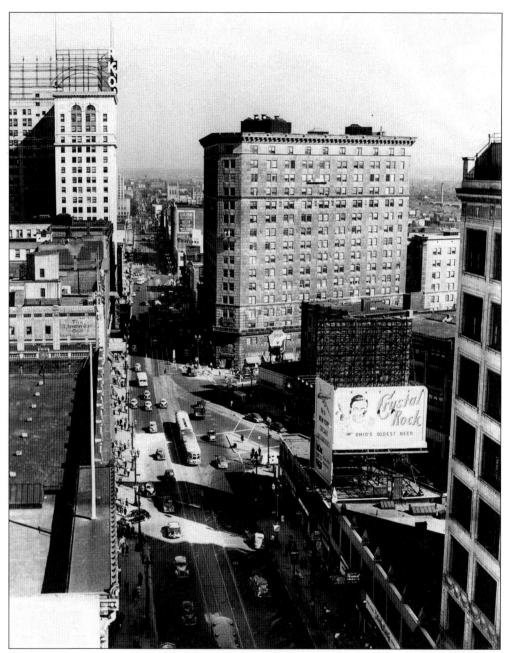

A Euclid Avenue streetcar heads east at the start of Playhouse Square. The Hanna Building is on the right, and the Keith Building, home of the Palace Theater, frames the scene on the left. (Bruce Young collection.)

Three

THE DETROIT-SUPERIOR
SUBWAY

Perhaps the most fondly remembered element of the streetcar era in Cleveland was a trip over the Detroit-Superior Bridge Subway. The double-deck Detroit-Superior high level bridge opened in 1917, replacing the old open-draw Superior Viaduct. Its upper deck was for rubber-tire vehicles, the lower one for streetcars. The new bridge not only eliminated a major bottleneck for west side residents trying to get downtown, the lower streetcar deck gave them a thrilling ride. The bridge subway was just over 3,000 feet in length.

Streetcars heading towards downtown via West 25th Street descended a ramp to a subway portal just north of Franklin Avenue. The ramp for Fulton, Detroit, and Clifton streetcars began on Detroit Avenue just east of West 29th Street. At the bottom of the ramp, the cars pulled into the subway's West 25th Street Station. After that stop the streetcars gathered speed. As they crossed the center span, passengers peeking through the open ties could glimpse the Cuyahoga River, 96 feet below. The streetcars then slowed for a stop at the West 9th Street Station. Then the cars rumbled forward where they once again came into the open and climbed a four-track ramp to Superior Avenue at West 6th Street.

Streetcars first used the subway on December 24, 1917, and the subway continued in use until January 24, 1954, when car 4142 left Public Square after a day of free rides, marking the last day of streetcars in the city. Shortly thereafter the ramps leading to the lower deck were paved over, and the city's best streetcar ride became only a memory.

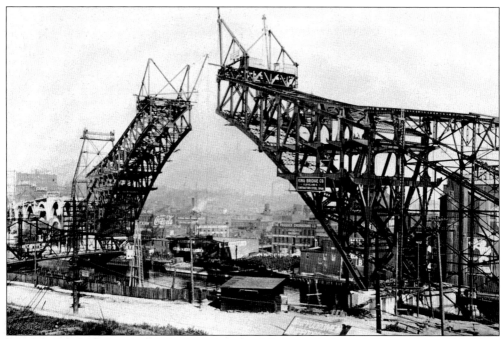

Clevelanders eagerly awaited the completion of the new high-level Detroit-Superior Bridge, which promised to greatly ease the flow of traffic to and from the west side of the city. The crown of the bridge was 196 feet above the Cuyahoga River. This scene is from September 29, 1915. (Jim Spangler collection).

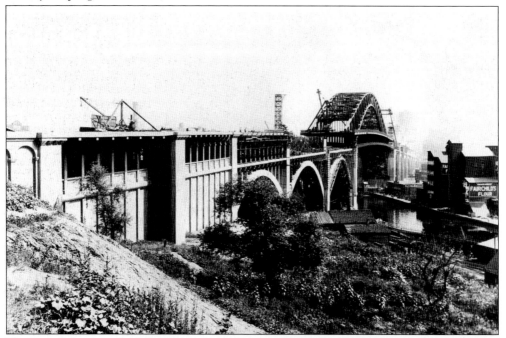

The Detroit-Superior Bridge is nearing completion in this photograph. Its two-deck structure is clearly visible. The top deck was for automobiles and trucks. The lower deck was for streetcars and interurbans. (Cuyahoga County Engineers photograph, Jim Spangler collection.)

The sign in the West 25th Street subway station could be a bit misleading. It points south for tracks that were actually north of this platform. To get there, riders would have to take a stairway down and cross under the West 25th Street platform to reach the northern platform. (Robert Runyon photograph, Bruce Young collection.)

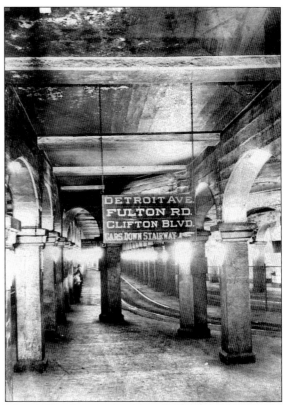

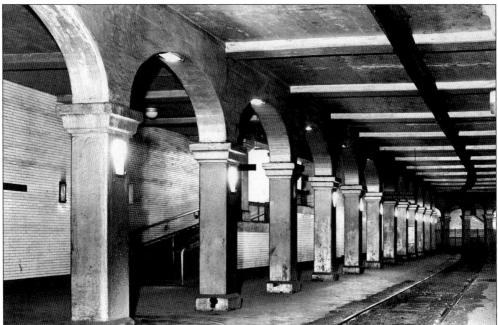

The view here is of the West 25th Street subway station, with the inbound track for the West 25th Street lines. The stairway on the left led to an entrance on the southeast corner of West 25th Street and Detroit Avenue. (*Cleveland Press* photograph, Jim Spangler collection.)

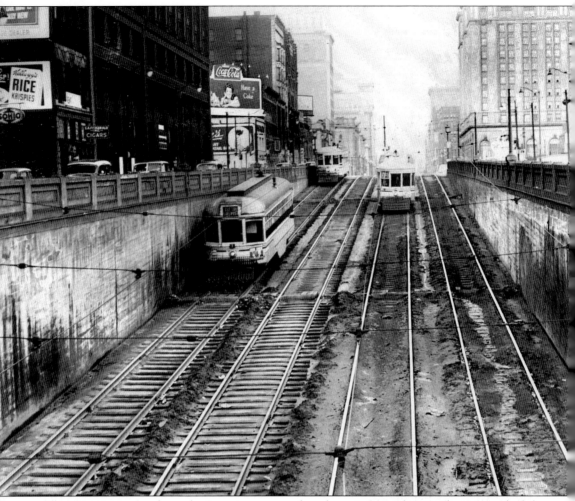

Three streetcars race down the Superior ramp to the subway in May of 1946. The cars on the left were heading to Clifton Boulevard and Detroit Avenue. The car on the right was headed to the West 137th Street loop in Lorain Avenue service. (J. William Vigrass photograph.)

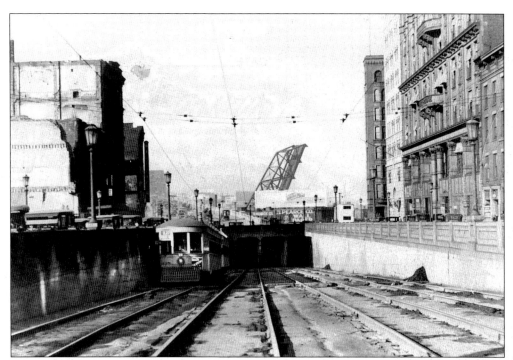

In September 1926, Cleveland Railway car 427 climbs the ramp to West 6th Street. On the left stands a building soon to be demolished to make way for the railroad viaduct for the new Cleveland Union Terminal development. On the right is the Perry Payne Building. (Jim Spangler collection.)

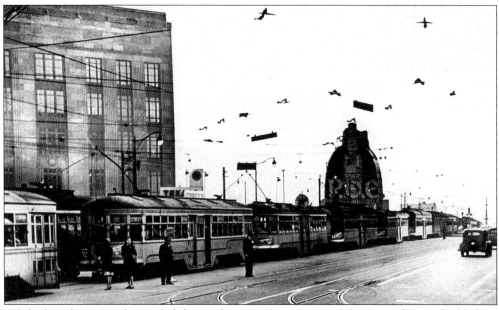

While the subway greatly speeded the trip between downtown and the west side, one disabled car could significantly disrupt service. On May 26, 1947, a derailment resulted in a long line of cars stalled on Superior Avenue. The U.S. post office building is to the left. (Jim Spangler collection.)

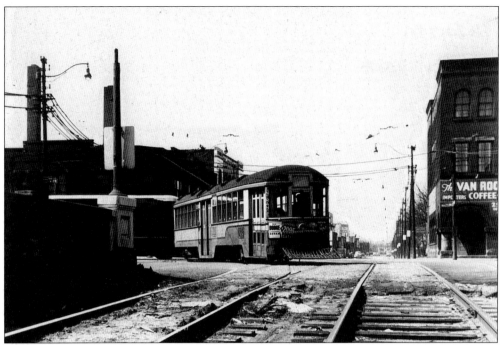

CTS 171 is turning from West 29th Street to the Detroit Avenue portal of the Detroit-Superior Bridge. The car is not in revenue service; it is on its way to Harvard Yard for scrapping in April 1952. (Jim Spangler photograph.)

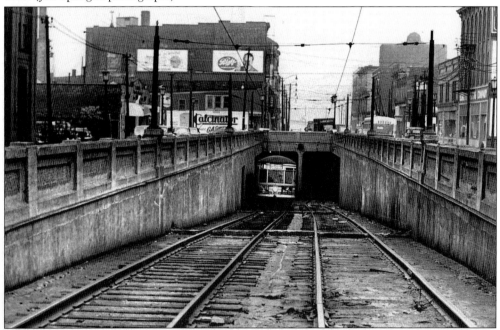

CTS 4113 is leaving the subway, outbound in Detroit Avenue service. At this point in time, the Detroit Avenue line is the only one still using the Detroit portal. To the right can be seen a trackless trolley, which has replaced streetcar service on the two other lines that formerly used this portal. (Robert Runyon photograph.)

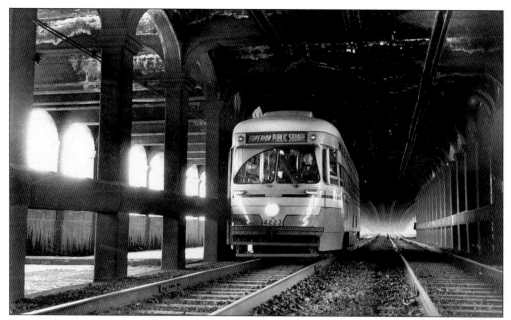

During the March 8, 1953, Cleveland Railway Club fan trip, PCC 4223 poses for photographers on the former outbound Detroit Avenue track. The track had not been in regular service since the Detroit line was converted in August 1951. A fan has been toying with the car's destination sign. (Cliff Scholes photograph, Jim Spangler collection.)

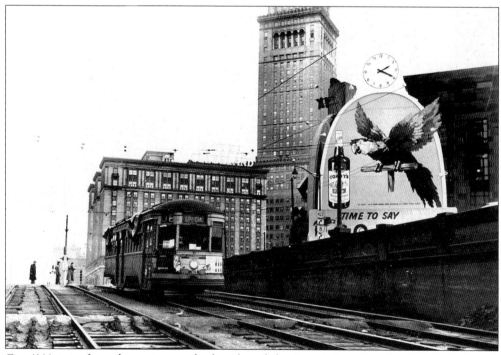

Car 4144 is in free-ride service on the last day of the Detroit-Superior subway. It is outbound, accelerating down the ramp from West 6th Street on January 24, 1954. (Jim Spangler photograph.)

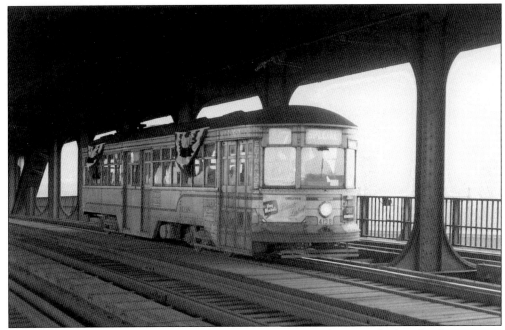

CTS 4138 is crossing the center span of the Detroit-Superior subway on the last day for streetcars in Cleveland. The car will carry its nostalgic riders to West 65th Street and Bridge Avenue before returning them back to Public Square. (Anthony F. Krisak photograph, Richard Krisak collection.)

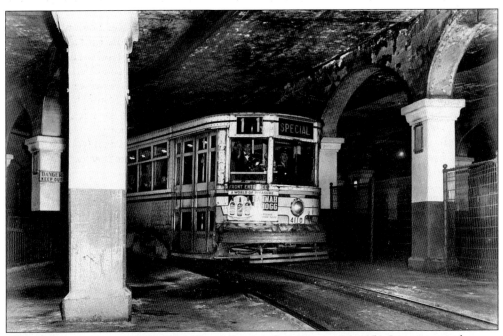

CTS 4110 is entering the West 25th Street Station. It is January 24, 1954. In just a couple more hours this scene will never again be experienced. The streetcar is filled with nostalgic riders taking one last ride to keep alive their memories of streetcar days in Cleveland. (*Cleveland Press* photograph, Jim Spangler collection.)

Four

THE WEST SIDE LINES

A few streetcar lines on the west side faded early (Scranton in 1929, Fairfield in 1935), and the short dinkey shuttle lines like the Pearl, State, Broadview, and Clark-Pershing Bridge were all gone by 1939. For most of the remaining Cleveland Railway-Cleveland Transit System era, the west side of Cleveland was served by ten major streetcar lines. Nine of the lines radiated westward from Public Square—Clifton, Detroit, Fulton, Madison, Lorain, Clark, and the three branches of the West 25th Street line to Broadview, State, and Pearl roads. One other route, the Harvard-Denison line, was a crosstown, east-west service. All of these lines, except for the Harvard-Denison route, used the Detroit-Superior subway.

The west side streetcars operated out of four stations. The Rocky River Station, located at Detroit Road and Sloan Avenue, served the Detroit and Clifton lines. Its yard also housed a freight station for the Lake Shore Electric Interurban line. Madison Station, on West 117th Street, served only the Madison Line. Denison Station, at West 73rd Street and Denison Avenue, was home base for the Fulton and Clark routes. It also served the Lorain Avenue line after an older station at Lorain Avenue and West 98th Street was closed in 1930. Brooklyn Station, at West 35th Street and Pearl Road served the three branches of the West 25th Street line. The Harvard-Denison route operated from the east side East 55th Street Station.

All of these operating stations have disappeared over time except for Brooklyn, which, after the end of streetcar service, became a bus garage and has remained in that capacity to the present time.

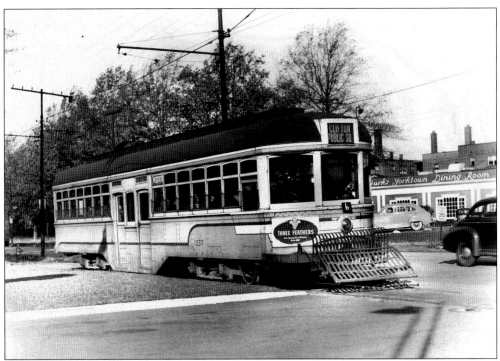

CTS 1237 is crossing West 117th Street on an eastbound trip. Clark's Yorktown Dining Room, one of the Cleveland chain's several popular restaurants, is at the right. (Jim Spangler collection.)

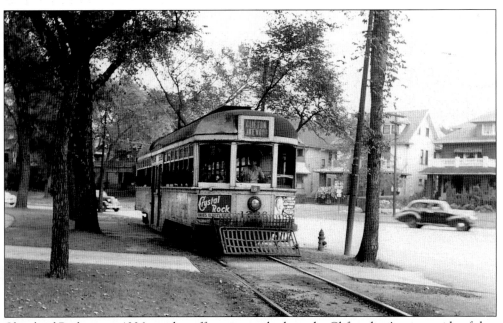

Cleveland Railway car 1236 avoids traffic as it travels along the Clifton line's private side-of-the-road right-of-way which stretched from Baltic Avenue in Cleveland all the way to West Clifton Boulevard in Lakewood. Its five miles of traffic-segregated track was the longest stretch in the system. (Brother Bernard Polinak photograph, Richard Krisak collection.)

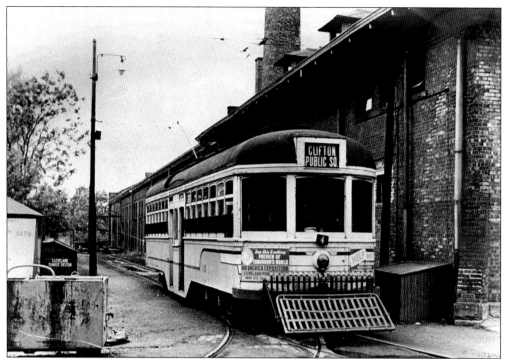

In summer 1945, CTS car 1281 is at the end of the Clifton Boulevard line at Rocky River Station. Scenes such as this had only two more years to go. The Clifton line was converted to buses in November 1947, and then in 1949 the inner portion of the line from West 117th Street to downtown was turned over to trackless trolleys. (Jim Spangler collection.)

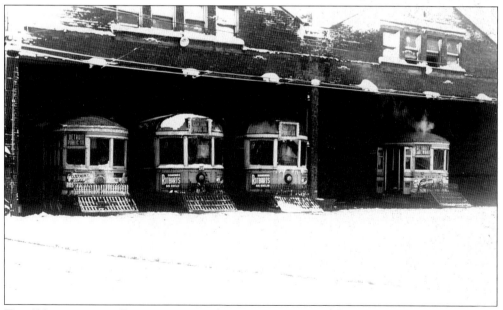

Two 400-series cars in Detroit service and two 1200-series in Clifton service rest in Rocky River Station on a snowy winter day in 1942. The smoke coming from one 400-series car is a sign that its coal stove is working overtime. (Jim Spangler collection.)

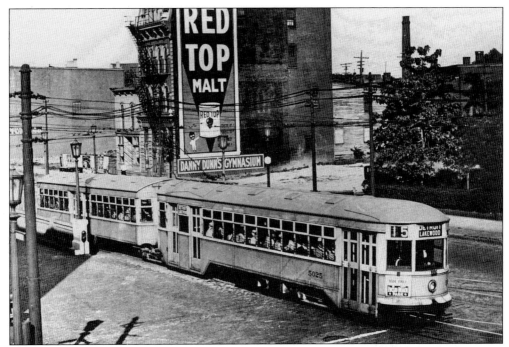

An articulated car in its original yellow Cleveland Railway colors is westbound on Detroit Avenue at West 29th Street. The car is just emerging from the ramp from the Detroit-Superior subway in 1935. (Jim Spangler collection.)

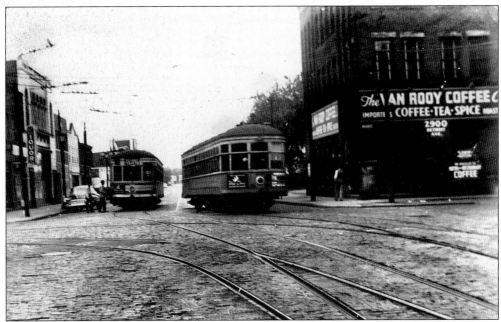

Streetcars meet on Detroit Avenue at West 29th Street just west of the subway. The tracks bearing to the left were for Fulton Road cars. In case of an accident blocking the West 25th Street subway section, these tracks were also used as an emergency bypass route to take streetcars back to their regular route via Franklin Boulevard. (Bill Cook photograph.)

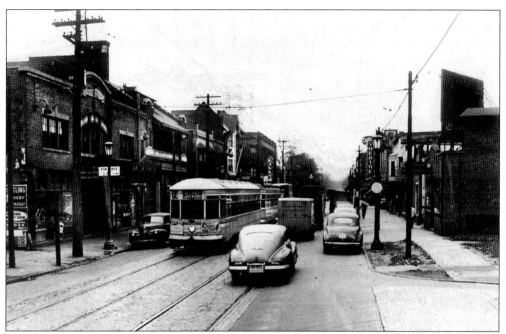

The busy Detroit line was often served by either the 5000-series articulated-cars or by trailer trains. Here car 4125 pulls a trailer in the commercial stretch of Detroit Avenue near West 65th Street. (*Cleveland Press* photograph, Jim Spangler collection.)

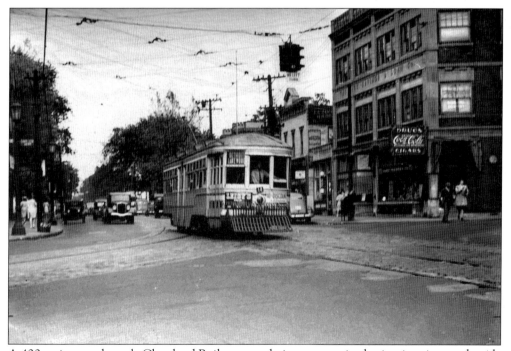

A 400-series car, the only Cleveland Railway–era design to carry its destination sign on the side rather than the middle of the front end, is crossing Lake Avenue on Detroit. At this junction, Clifton Boulevard cars turned north onto Lake Avenue. (J. William Vigrass photograph.)

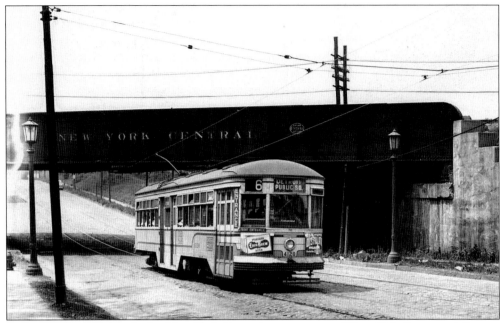

CTS 4120 passes beneath the New York Central overpass near West 98th Street and Detroit Avenue in June 1951. In four more years the new CTS rapid transit system would be crossing Detroit in this same area. The rapid transit system, however, used an underpass to cross the avenue. (Anthony F. Krisak photograph, Richard Krisak collection.)

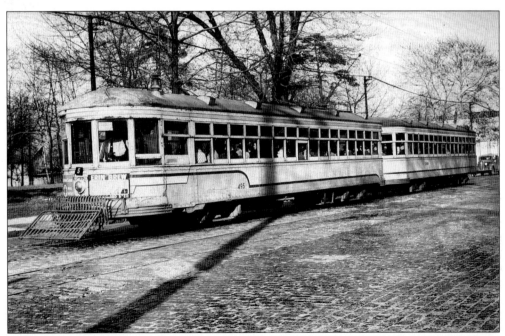

In this leafy 1946 view, a trailer train stops on Detroit Avenue at Alameda Street. Motor car 495 is pulling matching trailer 2494. The matched pair was a signature Cleveland streetcar–era scene. (J. William Vigrass photograph.)

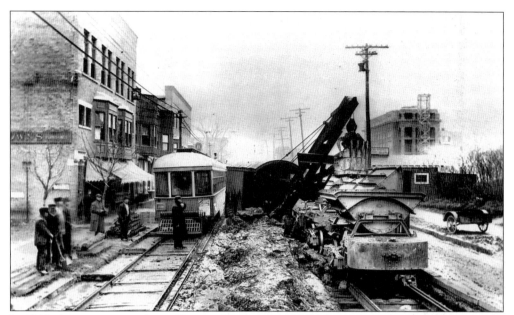

In 1916, the streetcar tracks on Detroit Avenue, near Belle Avenue, are being replaced. In the right background, construction is underway on Lakewood Hospital. (*Cleveland Press* archives of the Cleveland State University Libraries.)

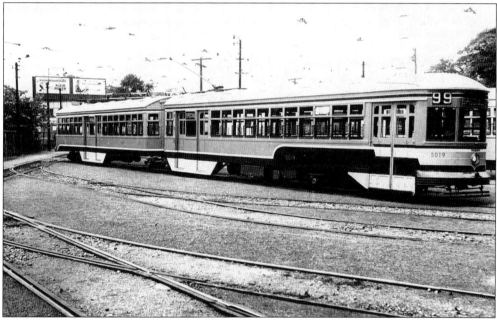

Cleveland Railway's 5000-series articulated-fleet only operated on two lines: Detroit Avenue and Euclid Avenue. In Rocky River yard, car 5019 is sporting its new green, grey, and white paint scheme in 1940. The new colors had replaced the system's familiar yellow livery in 1939, but the company soon noted an increase in accidents. Attributing the increase to the darker colors of the new scheme, officials changed the design again in 1941 to a cream, mustard-yellow, brown combination that remained the streetcar colors through their final years of service. (Jim Spangler collection.)

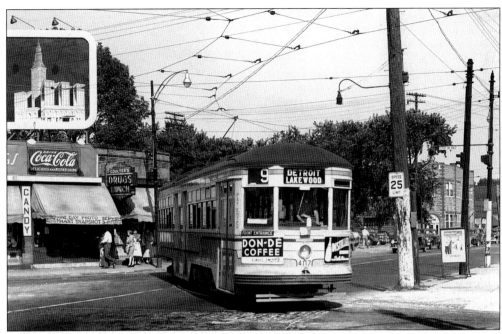

Detroit car 4117 has reached the western end of the Detroit Avenue line and is turning into Rocky River Station. Across the street a billboard shows the Terminal Tower Complex at the downtown end of the car line. (Anthony F. Krisak photograph, Richard Krisak collection.)

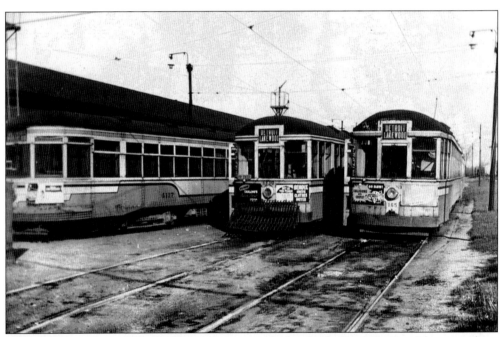

Three different series of Cleveland streetcars are parked in Rocky River Station. The scene dates from 1951. The Clifton line has been converted, and only the Detroit Avenue line still uses the car yard. (Roy Bruce photograph.)

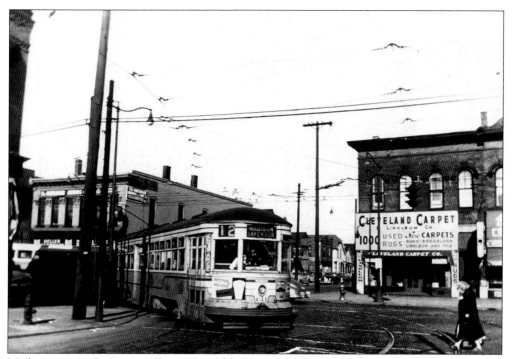

Madison car 4145 is turning from West 25th Street onto Bridge Avenue in the fall of 1952. The streetcar will follow Bridge Avenue to West 65th Street, before switching to Madison Avenue for its trip to Rocky River Drive in Lakewood. (Roy Bruce photograph.)

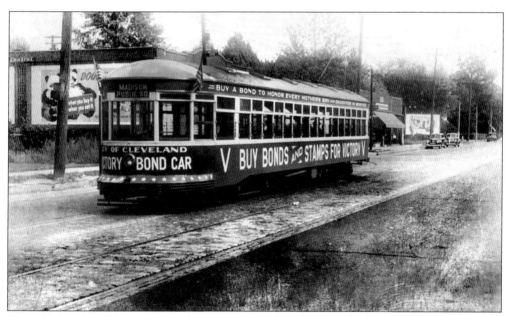

Car 4113 is painted in patriotic colors to promote the sale of World War II victory bonds. The car is at the end of the line and will back into Spring Garden Avenue where it will wait a few minutes before departing on its next trip downtown. (Jim Spangler collection.)

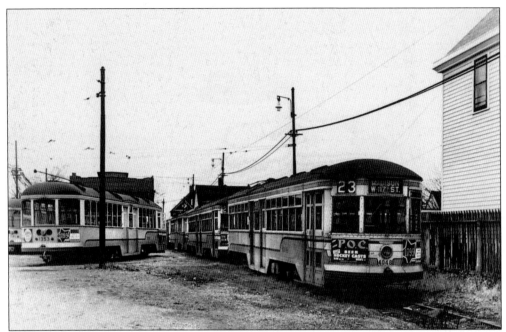

Transit workers called a strike against the Cleveland Transit System on December 22, 1949, at the height of the Christmas shopping season. While the strike only lasted five days, no doubt some disgruntled passengers were tempted by the car's advertising of a brand new Dodge automobile for $1,795. This scene is of strike-idled streetcars at Madison Station. (Jim Spangler collection.)

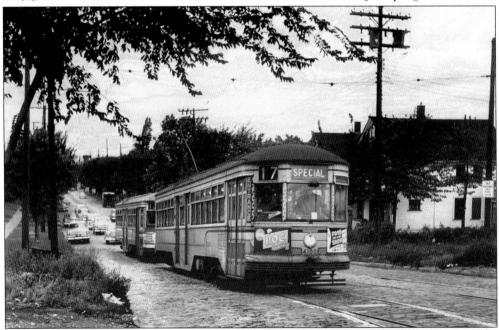

Passenger cars sometimes had to act as work cars. Car 4100 is towing a sister car to Denison Station in September 1953. Madison Station had been closed due to a gas-line explosion, forcing the Madison line to operate from Denison Station for its few remaining months of service. (Jim Spangler photograph.)

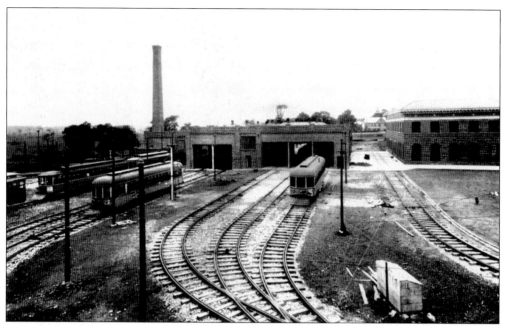

Denison Station was one of the first major improvements made to the streetcar system after the Cleveland Railway Company gained control in 1910. The station is new in this 1916 view. (Cleveland Railway photograph, Jim Spangler collection.)

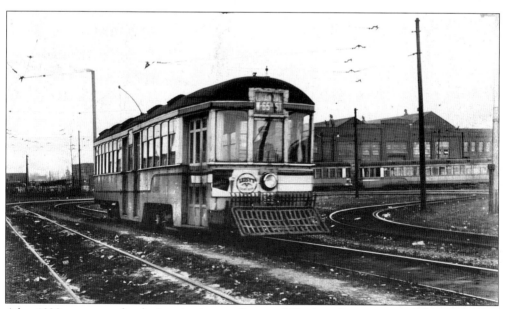

After 1930, streetcars for the Lorain Avenue line used Denison Station, one of three lines that operated from there. In 1948, car 1348 is leaving the station for evening rush-hour service on Lorain Avenue. (Jim Spangler photograph.)

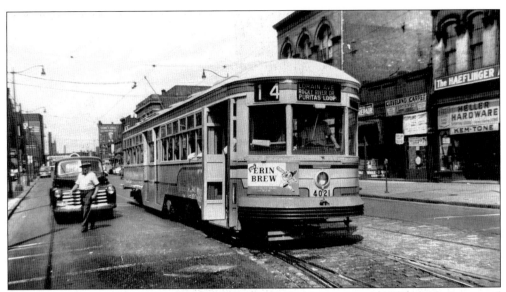

The new paint job on car 4021 gleams as a Lorain Avenue car pauses at West 25th Street and Bridge Avenue. The car will continue along West 25th another two blocks before turning west onto Lorain Avenue. (Bruce Young collection.)

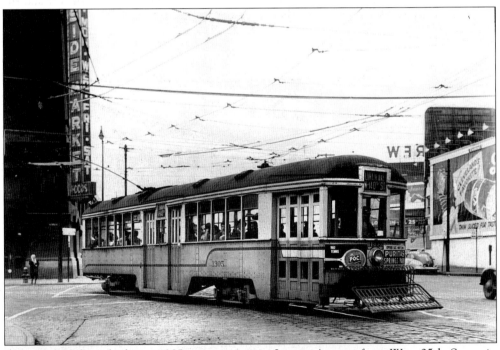

Cleveland Railway–built car 1305 is turning onto Lorain Avenue from West 25th Street in June 1952 during the last week of streetcar service on the line. The 1300-series cars were the last streetcars to have both a conductor and a motorman. The West Side Market is in the background. (Jim Spangler photograph.)

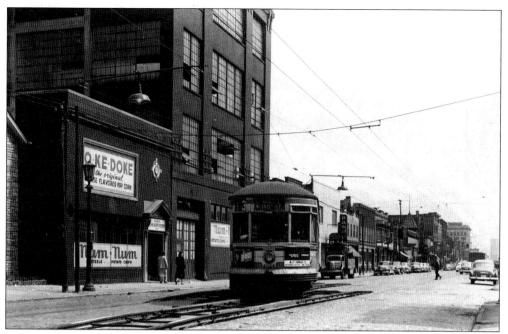

Sewer work required a portion of the Lorain Avenue westbound track to be torn up. A crossover allowed the car to bypass the disrupted section by using the eastbound track. In April 1952, the car is passing the Num Num Potato Chip factory at West 42nd Street. Both the car and the potato chip company are now history. (Jim Spangler photograph.)

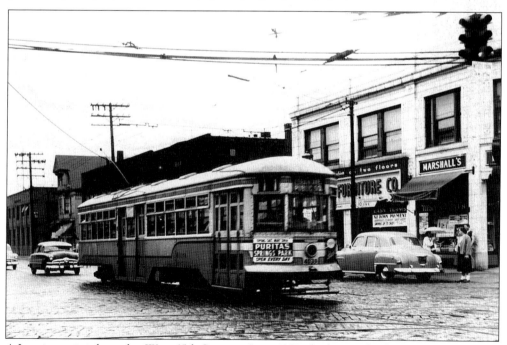

A Lorain car is inbound at West 65th Street in June 1952, the last week of streetcar service. The tracks on West 65th, which were once used by the crosstown Harvard Denison line, remained in use to get Lorain cars to and from Denison Station. (Jim Spangler photograph.)

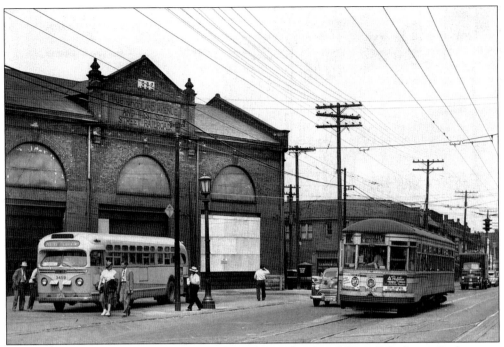

A Lorain Avenue car pauses in front of the old Woodland and West Side Street Railway car barn at West 98th Street. The streetcar will go to the West 140th Street loop. The bus will go to Puritas Springs Park, a popular Cleveland amusement park. (Anthony F. Krisak photograph, Richard Krisak collection.)

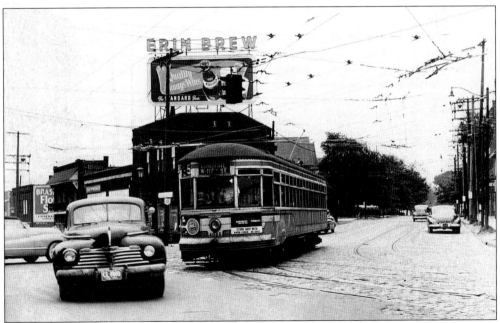

Car 4045 is turning onto Lorain Avenue from Denison Avenue. The car is in non-revenue service, approaching the line from Denison Station. The wye for cars turning onto Clark Avenue can be seen slightly beyond the rear of the car. (Jim Spangler photograph.)

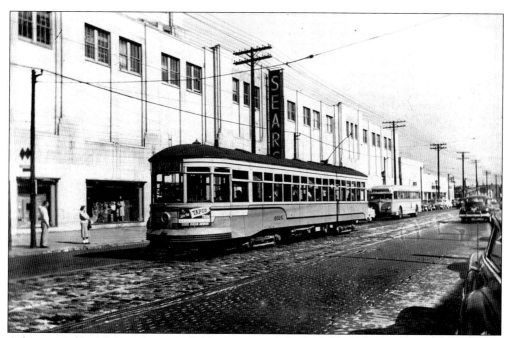

A large number of passengers used the streetcar to reach the Sears, Roebuck store at Lorain Avenue and West 110th Street. The bus trailing the streetcar was a Lorain Express. It went out to Puritas Road. (Roy Bruce photograph.)

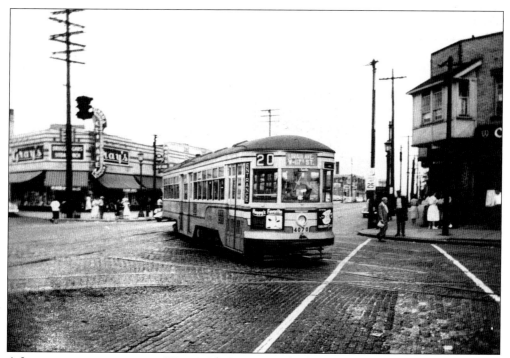

A Lorain car is turning onto West 117th Street. At the left is a Gray's Drug Store. The right corner was the home of a Cleveland Trust bank branch. After streetcar service ended, the bank built a new branch office on the site of the former West 117th loop. (Bill Cook photograph.)

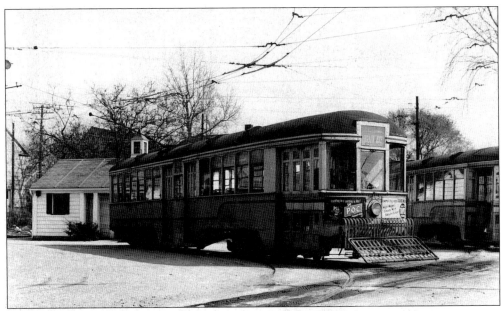

Two streetcars wait in the West 140th Street loop at the end of the Lorain Avenue streetcar line. This loop entered service in 1947, replacing an earlier one at West 137th Street. This loop lasted until the end of Lorain streetcar service on June 14, 1952. It then served the trackless trolleys which replaced the streetcars. The building to the rear was a rest station for the crew. (Jim Spangler photograph.)

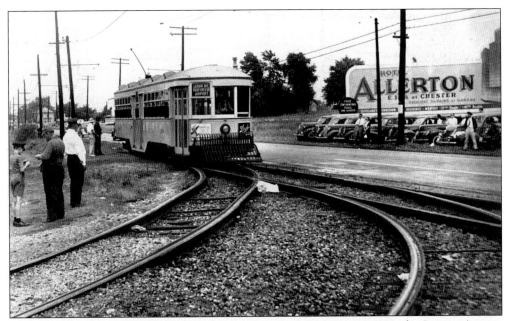

After the Cleveland Southwestern interurban line ended service in 1931, the Lorain Avenue streetcar line was extended over the Southwestern tracks via Rocky River Drive to Brookpark Road, near Cleveland Airport. Lorain service continued to the airport on an intermittent basis until 1939. (Jim Spangler collection.)

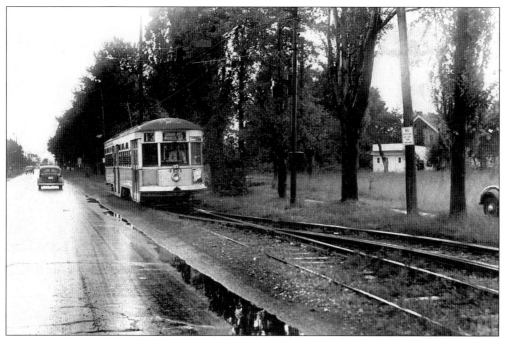

Cleveland Railway 4131 is inbound on Rocky River Drive at Maplewood in 1938. The mostly single-track line had some two-track passing sections to facilitate both north and southbound traffic. (Jim Spangler collection.)

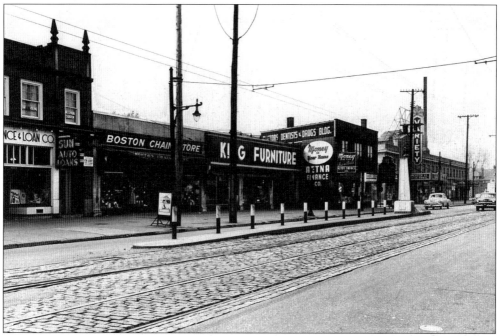

Streetcars stopped plying the Lorain Avenue rails on June 14, 1952. It took a while, however, for all traces to disappear. Five months later, the passenger safety island and the rails are still in place. The trackless trolley overhead, however, shows the new mode is in place. Trackless trolleys picked up their passengers at the curb. (Robert Runyon photograph, Bruce Young collection.)

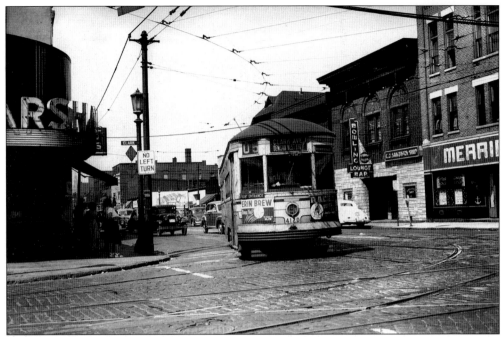

Car 4120 turns from West 25th Street onto Clark Avenue in 1949. The line followed Clark Avenue to West 73rd Street. The cars turned south on West 73rd to Denison Avenue, and then followed along Denison to a wye at West 100th Street, just east of Lorain Avenue. (J. William Vigrass photograph.)

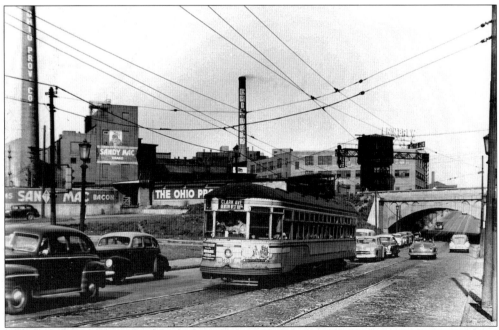

A Clark Avenue streetcar has just passed two familiar west-side landmarks, the Standard Brewing Company's Erin Brew facility and the Ohio Provision meat packing plant. The streetcar is approaching West 65th Street. (Robert Runyon photograph.)

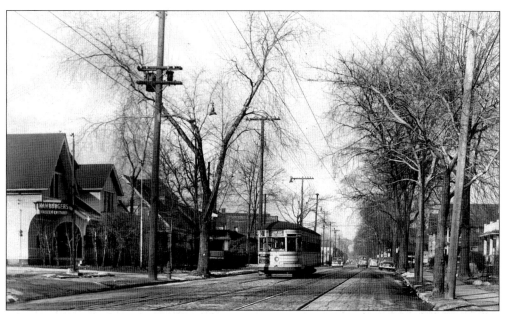

CTS 4053 is inbound on Denison Avenue at West 76th Street in January 1953. While the brick-paved street caused a rumble in automobiles, the streetcar could glide smoothly by on its steel track. (Robert Runyon photograph.)

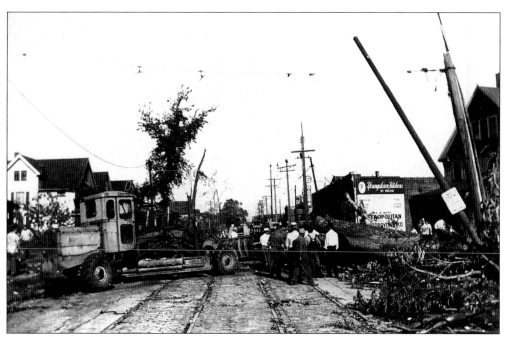

A tornado struck the west side of Cleveland in June 1953. On June 7, 1953, at West 98th Street and Denison Avenue, work crews are removing fallen trees from the track. They also had to replace the trolley wire downed by the storm. (Roy Bruce photograph.)

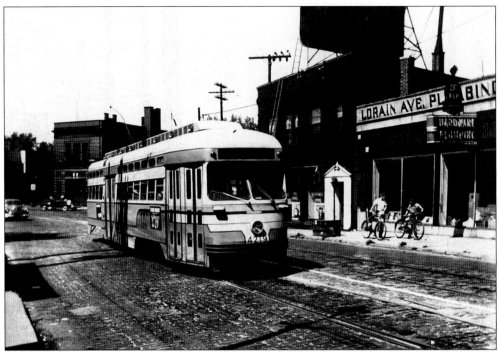

The Clark Avenue streetcar line was briefly served by the PCC cars. In July 1950, transit liner 4219 is inbound on Denison Avenue. Lorain Avenue is in the background. (Roy Bruce photograph.)

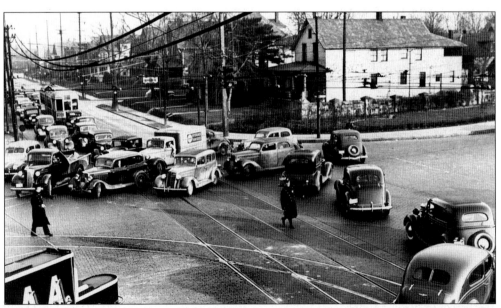

Not many drivers today can recall the days of the old rotary turn when motorists wishing to turn left first had to turn right and loop around to the direction they wanted to go. The rotary turn did not facilitate smooth traffic flow, nor did it quickly open the path for the streetcar. This scene is at Fulton Road and Denison Avenue in 1938. (*Cleveland Press* photograph, Jim Spangler collection.)

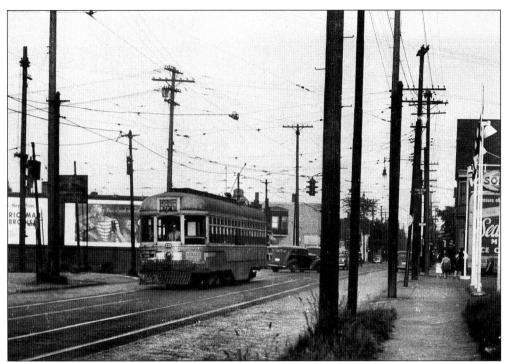

A center-door Fulton car passes West 65th Street on Denison Avenue. The Fulton line followed Denison Avenue from Fulton to Denison Station at West 73rd Street. (Jim Spangler collection.)

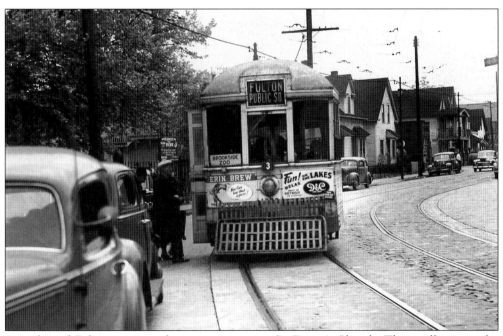

An inbound Fulton car stops for a passenger near St. Rocco's Church. The small sign in the front window reminds riders that the Fulton line was a good way to get to the zoo. (Anthony F. Krisak photograph, Richard Krisak collection.)

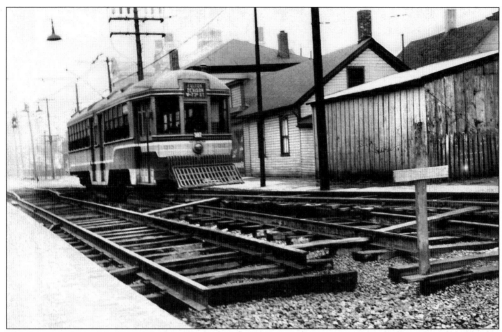

In 1941, a Fulton Road car in Cleveland Railway's short-lived grey and green livery, is proceeding carefully over temporary track. Walton School is in the background. (Jim Spangler collection.)

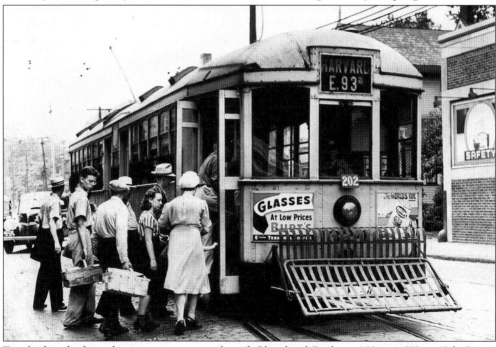

Finished with their shopping, passengers board Cleveland Railway 1324 on West 65th Street at Detroit Avenue. The Harvard-Denison car had left its west side Edgewater loop and would follow West 65th Street to Denison Avenue where it would proceed east. Denison Avenue became Harvard Avenue on the east side; the eastern end of the line was at East 93rd Street. (Jim Spangler collection.)

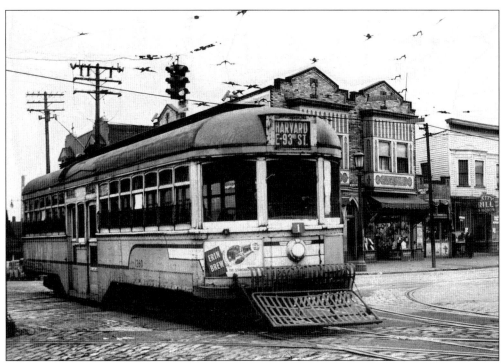

CTS 1260 clanks its way over cross-tracks at West 65th Street and Detroit Avenue. This area was lined with stores, a popular shopping district. The car is southbound. (Jim Toman collection.)

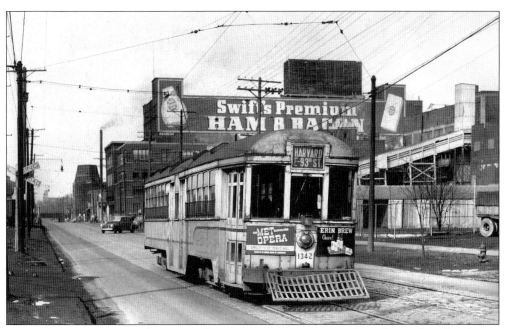

Harvard-Denison car 1342 has stopped on Denison Avenue across from the stockyards. The car is about to cross over a railroad track. As a safety precaution, conductors had to set and hold the derailer device before the car could proceed. After the car passed through the intersection, the conductor would hop back on. (Anthony F. Krisak photograph, Richard Krisak collection.)

The sign informs passersby that the road reconstruction underway is a WPA project. In January 1942, Cleveland Railway 1327 eases through the Denison-West 25th Street intersection. (Jim Spangler collection.)

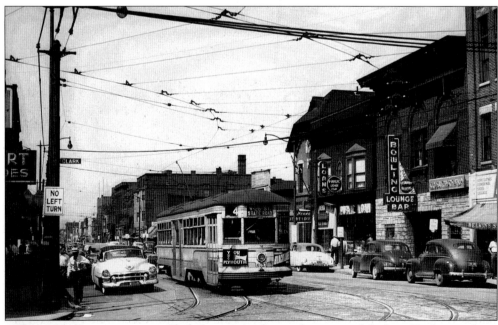

A West 25th Street car stops at Clark Avenue on the trunk portion of the line. Farther south on West 25th Street, the line will break into three branches. Car 4097 will follow the State Road branch to its terminus on Brookpark Road. (J. William Vigrass photograph.)

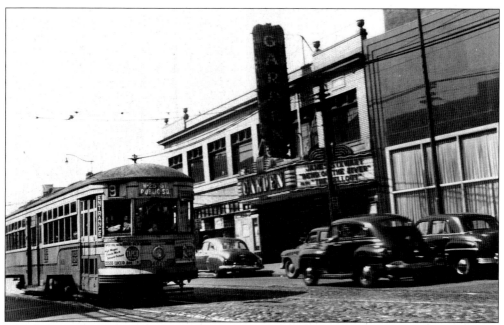

Like the streetcars, neighborhood movie theaters would also fade from the Cleveland scene. The Garden Theater is featuring a double bill. The date is April 3, 1952. (Bill Cook photograph.)

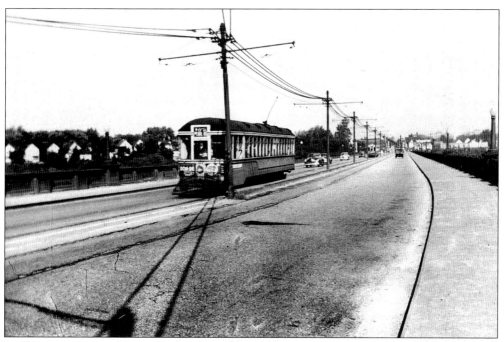

A 100-series car, southbound in Pearl Road branch service, is crossing the Brooklyn-Brighton Bridge. Cleveland Zoo is located in the valley to the left of the scene. West 25th Street had excellent streetcar service. A fleet of 62 cars was assigned to the line, meaning that in non-rush-hour service, people had less than four minutes to wait for the next streetcar to arrive. (Roy Bruce photograph.)

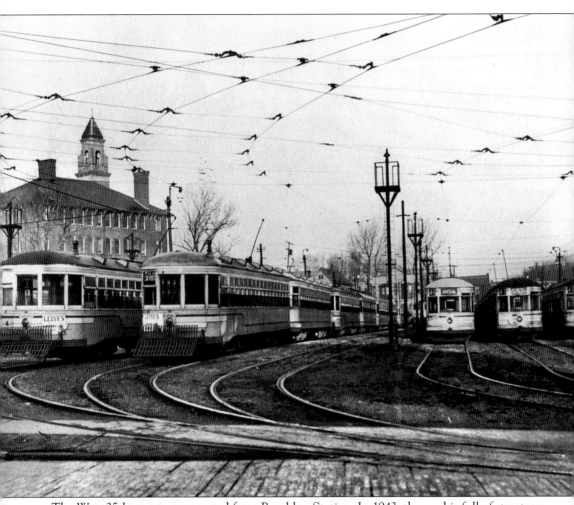

The West 25th streetcars operated from Brooklyn Station. In 1943, the yard is full of streetcars awaiting their call into service, 400-series cars are on the left and 4000-series cars are on the right. Our Lady of Good Counsel School is at the left. (Jim Spangler collection.)

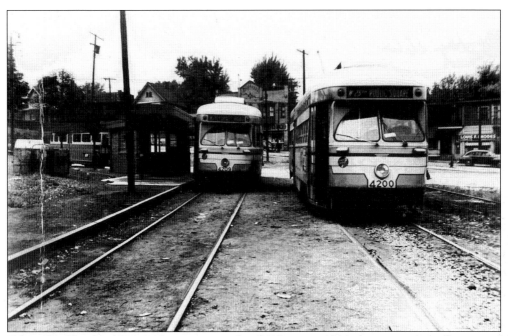

When the Cleveland Transit System received its PCC cars in 1946, they were originally assigned to east-side service. After west-side councilmen complained, 20 of the transit-liners were assigned to their side of town. Here two rest in Brooklyn Station in 1948. (Roy Bruce photograph.)

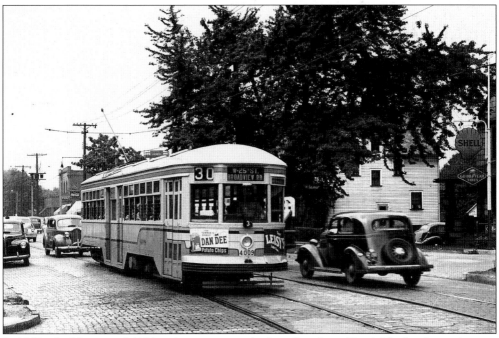

In 1947, a freshly painted 4009 makes its way south along Broadview Road. The brick-paved streets were a common sight at the time. (Anthony F. Krisak photograph, Richard Krisak collection.)

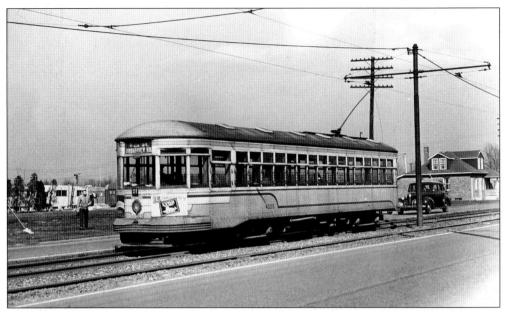

Only a short stretch of Brookpark Road between State and Broadview Roads carried streetcar tracks. In March 1947, CTS 4005 is in the Brookpark center reservation on its way to the West 33rd Street loop. A Packard automobile trails the car. (J. William Vigrass photograph.)

On June 15, 1950, PCC 4202, on the Broadview branch of the West 25th Street line, is turning onto Brookpark Road. The Broadview branch was converted to bus operation just three weeks later. (Bill Cook photograph.)

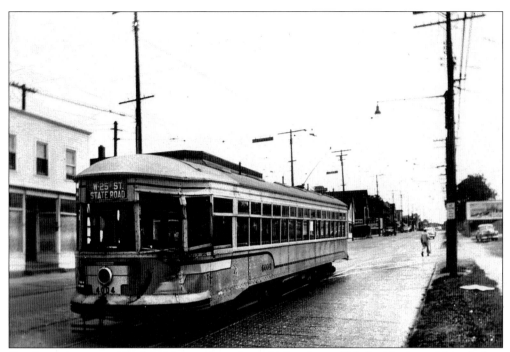

Sturdy streetcars usually fared better than the vehicles that collided with them. Nonetheless, they sometimes had to go to the shops for repair. In 1951, car 4004 waits outside Brooklyn Station before moving to Denison Station where it will be stored. (Roy Bruce photograph.)

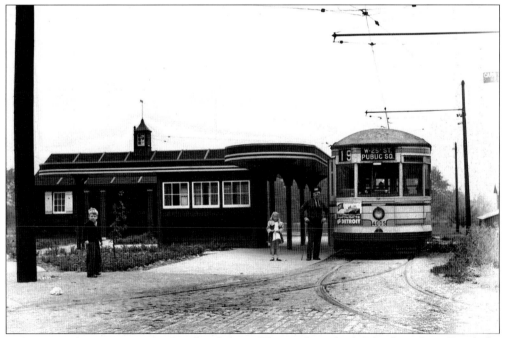

A State Road car waits in the Brookpark loop. The track to the left leads to State Road, the one on the right to Broadview Road. The children and motorman seem more interested in the photographer than in the streetcar. (Jim Spangler collection.)

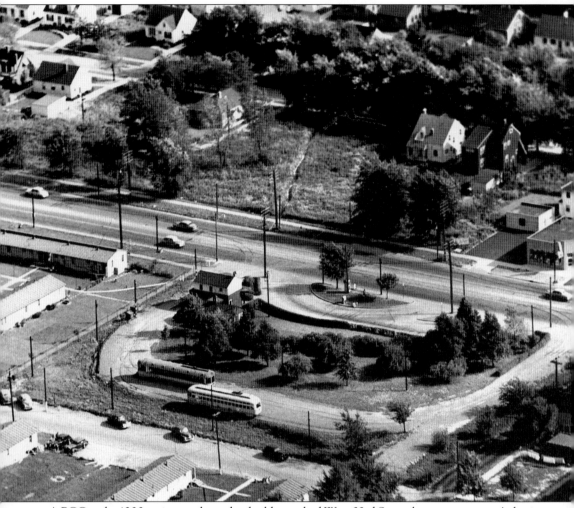

A PCC and a 4000-series car share the double-tracked West 33rd Street loop on a summer's day in 1951. The front part of the loop, nearest to Brookpark Road, was used for turning the Broadview buses after conversion of the line. (Robert Runyon photograph, Bruce Young collection.)

Five

THE EAST SIDE LINES

The streetcar scene on the east side of Cleveland was considerably more extensive than on the west side of town. Excluding dinkeys, Cleveland's east side was blessed with 19 streetcar lines during the Cleveland Railway era. Fifteen lines connected downtown Cleveland with some eastern or southeastern destination. Four others were crosstown lines. East-side streetcar route mileage was almost double that of the west side.

The east side was also served by more operating stations. These included St. Clair, Superior, Payne, Windermere, Cedar, Quincy, Woodhill, and East 55th Street. The Woodhill Station, on Woodhill Road between Buckeye and Kinsman, was home to seven streetcar lines, the busiest in the system. Two stations, Payne and Quincy, were closed to streetcars before World War II.

The east side was also home to Harvard Shops. Located on Harvard Avenue and East 49th Street, the shops were where all major repairs were made, and in the last days of the streetcars, where the streetcars were scrapped.

The east-side routes serving downtown were St. Clair, Superior, Payne, Wade Park, Euclid, Cedar, Mayfield, Fairmount, Woodland, Buckeye, Kinsman, Union, and Broadway. The crosstown lines were: East 30th, East 55th, East 79th, and East 105th. The Euclid and East 105th Street lines were the longest, each over ten miles in length.

Five east side lines were converted to rubber-tire operation before World War II—Payne in 1935, Wade Park in 1939, Central in 1938, and East 30th and East 79th in 1940. The last east side line was Superior Avenue. It was converted to trackless trolley operation on March 20, 1953.

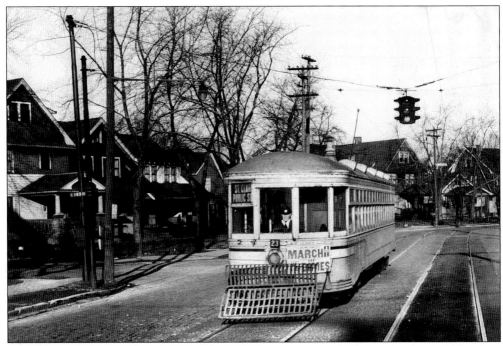

St. Clair car 396 is inbound on Lake Shore Boulevard at East 149th Street. The car is heading downtown from the Euclid Beach Park loop in March 1947. (J. William Vigrass photograph.)

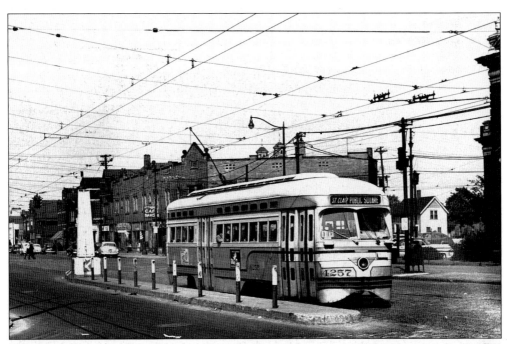

CTS 4257, a St. Louis Car Company PCC model, stops at the passenger island on St. Clair Avenue at East 55th Street. The double-wire overhead means that streetcars will soon be replaced by trackless trolleys on the line. (Anthony F. Krisak photograph, Richard Krisak collection.)

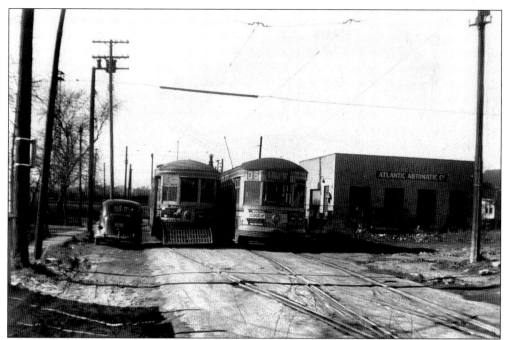

Brussels Road wye, the only two-track wye in the system, was another destination point for outbound St. Clair streetcars. It is April 5, 1951, in the above photograph and this portion of the St. Clair line will be converted to buses in just two more days. (Jim Spangler photograph.)

In 1935, an inbound Superior Avenue streetcar stops at East 18th Street in front of the Cleveland News Building. The *News* was an afternoon daily newspaper that served the city until 1960. The building then became home to the morning *Plain Dealer*. (Jim Spangler collection.)

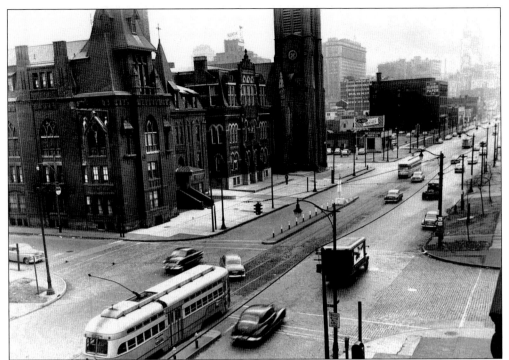

Two PCCs are about to pass in front of St. Peter's Church on Superior Avenue at East 17th Street. More of the modern PCC cars were in service on Superior Avenue than on any other line in December 1952. (Robert Runyon photograph.)

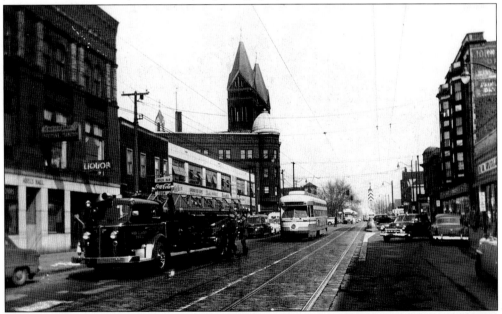

The capacity of emergency vehicles to immobilize streetcars was frequently cited as a reason that the cars should be replaced by more-flexible buses. Here a fire engine partially blocks the streetcar tracks on Superior Avenue at East 71st Street. Three PCCs wait for the track to be reopened. (Roy Bruce photograph.)

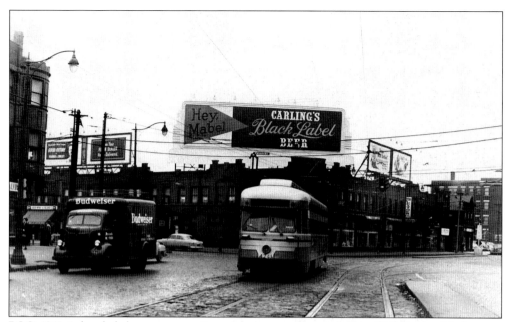

PCC 4241 is headed downtown on Superior Avenue, just past East 55th Street. Nothing in this scene remains today. The streetcar and the buildings are long gone. Even Carling's beer, once brewed in Cleveland, is a vanishing memory. (Robert Runyon photograph, Jim Spangler collection.)

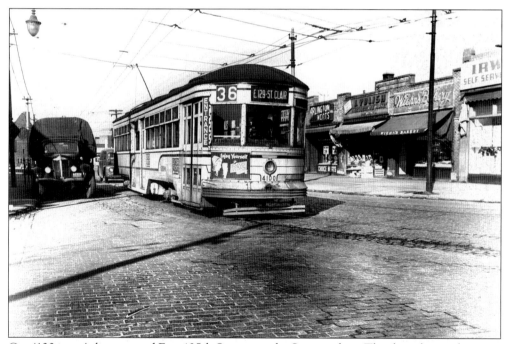

Car 4100 is at Arlington and East 125th Streets on the Superior line. The shops lining the street clearly depict what neighborhood shopping was like during the streetcar era. The presence of the overhead trackless trolley wires dates the scene to March 1953. (Robert Runyon photograph, Bruce Young collection.)

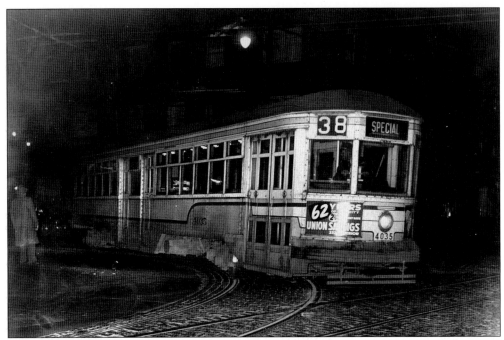

One of the last streetcars on the east side, 4035 turns from Superior onto East 55th Street. It will head north to the Marquette loop at St. Clair, and then return south. Its destination is Harvard Yard and ultimately the scrap line. The scene is March 21, 1953, at 3:00 a.m. (Jim Spangler photograph.)

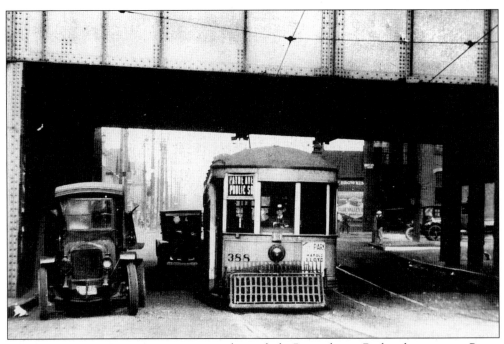

In 1923, a 400-series Payne Avenue car passes beneath the Pennsylvania Railroad overpass on Payne Avenue. The car is just west of East 40th Street on its way downtown. (Jim Spangler collection.)

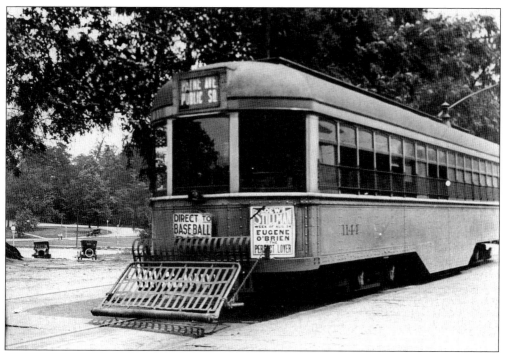

Center-entrance car 1144 rests at the Payne operating station in August 1919. This station, near East 105th Street and Hough Avenue in the University Circle neighborhood, was later converted for trackless trolley operation and became known in that era as Hough Station. (McKinley Crowley photograph, Jim Spangler collection.)

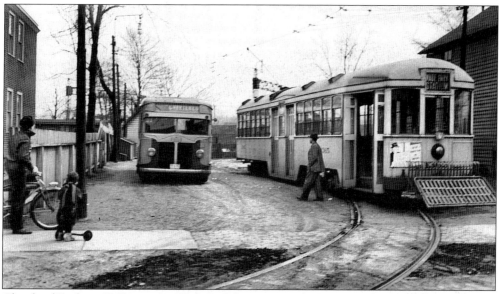

Cleveland Railway 1365 is in the Wade Park loop on April 15, 1939. It is the last day of streetcar service on the line. Cleveland Railway buses, like this 1938-model White Motor Coach in Cleveland Railway's new green paint scheme, will take over service on the Wade Park line. (Duane Bearse photograph, Herbert H. Harwood Jr., collection.)

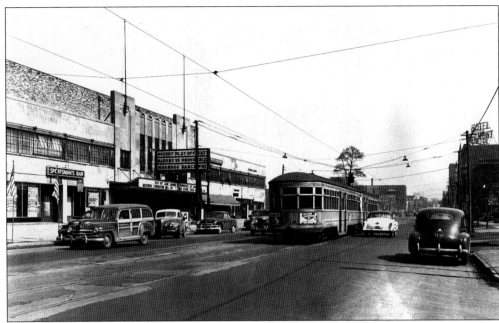

An articulated streetcar is eastbound on Euclid Avenue just past East 36th Street. The Cleveland Arena, home of the Cleveland Barons hockey team is to the left. The Euclid car line has only one more month to go in March 1952. The arena survived until 1977. The site is now the regional headquarters for the American Red Cross. (Robert Runyon photograph, Bruce Young collection.)

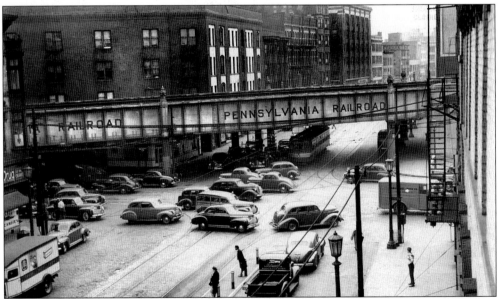

In August 1941, an inbound Euclid Avenue car stops beneath the Pennsylvania Railroad overpass at East 55th Street. A hamburger restaurant was situated on the northeast corner of the intersection. Some railroad passengers would disembark at the East 55th Street PRR station and take the Euclid streetcar west along the avenue into downtown. (*Cleveland Press* photograph, Jim Toman collection.)

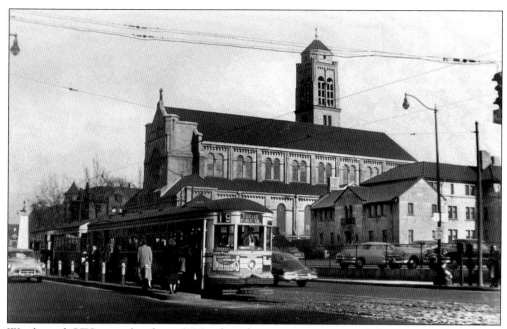

Westbound CTS articulated-car 5025 is boarding passengers on Euclid Avenue and East 79th Street. St. Agnes Church is in the background. It is April 25, 1952, and streetcar service on the Euclid line has only one more day to go. (Bill Cook photograph.)

Dressed for the weather, a lone passenger waits on a safety island near East 90th Street for the next inbound Euclid Avenue streetcar. She would not have long to wait. Euclid cars came by less than four minutes apart. (Robert Runyon photograph, Jim Spangler collection.)

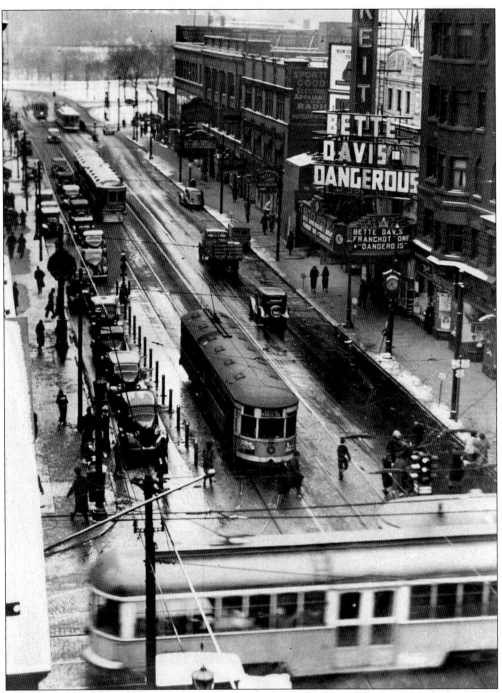

The Euclid Avenue/East 105th Street neighborhood was sometimes called Cleveland's second downtown. In this January 1936 morning scene, four streetcars can be seen on the busy Euclid line. An East 105th Street car is southbound. The view is toward the east. (*Cleveland Press* photograph, Jim Spangler collection.)

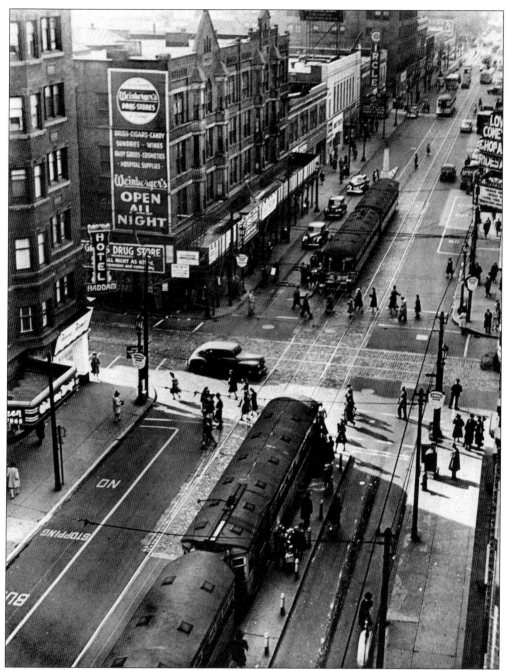

In November 1946, two articulated 5000s meet on Euclid Avenue at East 105th Street. The Haddam Hotel is to the left. A Fanny Farmer candy shop is on the hotel's first floor. (*Cleveland Press* photograph, Blaine Hays collection.)

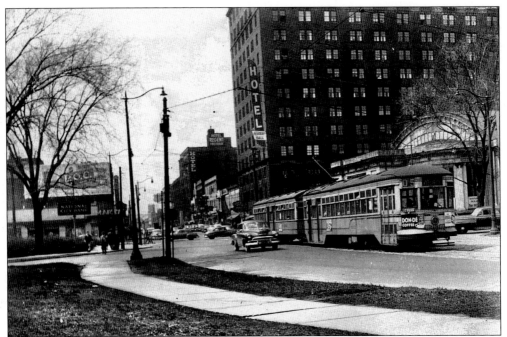

CTS 5024 has just crossed East 107th Street on its eastbound trip to Windermere. The building immediately behind the car is the Elysium, at one time the world's largest ice-skating rink. It was operated by the Humphrey family, which also owned Euclid Beach Park. The Fenway Hall Hotel is next to the rink. The Elysium was torn down in 1951. (Jim Spangler collection.)

The Euclid Avenue streetcar line had a branch to East 140th Street and Hayden Avenue. Articulated car 5010 glides along the private right-of-way, just east of the Windermere Car House on its way to Hayden. (Jim Spangler collection.)

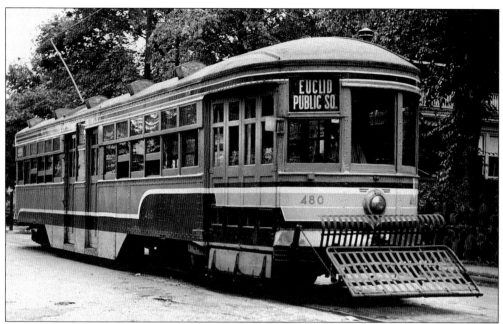

Cleveland Railway 480 in the company's new green, grey, and white paint is resting in the Catalpa Street wye at Euclid Avenue and Green Road in June 1940. (M. D. McCarter photograph.)

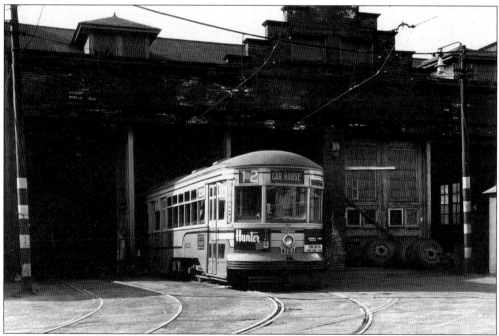

On April 26, 1952, there is only one 4000-series streetcar left in the Windermere Car House. After the other cars in the fleet had left, car 4123 remained to take part the next day in a Parade of Progress. It would mark the end of 92 years of Euclid Avenue streetcar service. (Jim Spangler photograph.)

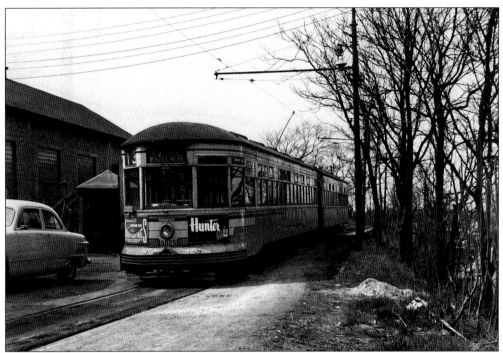

CTS 5025 has completed its last day of revenue service on Euclid Avenue. It remains at Windermere for its final ride down the avenue in the April 27, 1952, Parade of Progress. (Jim Spangler photograph.)

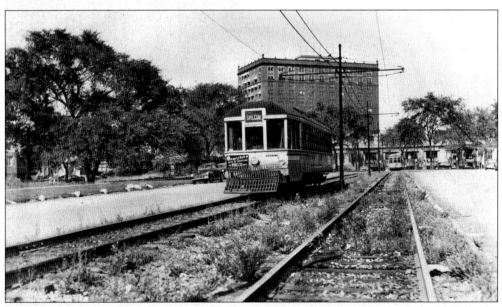

A private right-of-way connected Euclid Avenue with Cedar Glen. This car is headed for the loop there where it will turn and await its return trip. It is in Euclid-Lorain service. The building in the background is the Fenway Hall Hotel, now a facility of the Hospice of the Western Reserve. (Jim Spangler collection.)

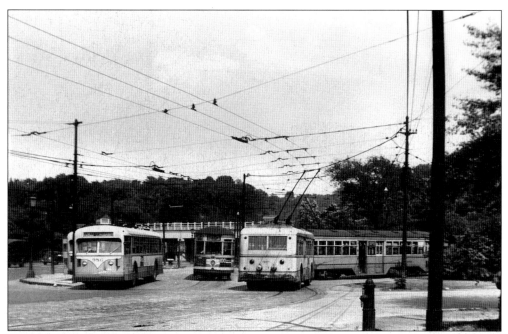

Cedar Glen was a busy transit stop. A Mayfield streetcar is heading downtown and then to the west side via Lorain Avenue. Another streetcar enters the loop, and a trackless trolley serving the Cedar Avenue line awaits its turn on June 27, 1949. (Bill Cook photograph.)

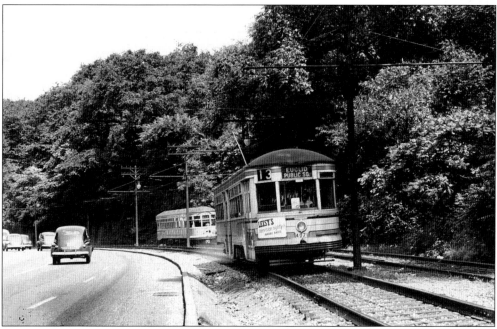

In 1948, CTS 4071 is on the private right-of-way on the side of Cedar Road hill. The hillside tracks served the streetcars on the Cedar, Fairmount, and Mayfield lines. After the streetcars stopped running, the right-of-way was preserved for a time as a possible extension of the rapid transit line to the Heights. (J. William Vigrass photograph.)

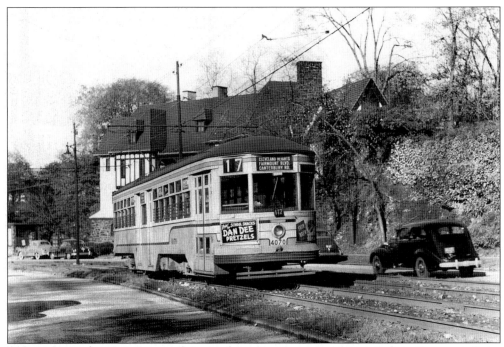

A Fairmount streetcar has entered the boulevard's center reservation which will carry it all the way to Canterbury Road. This location is just east of the intersection of Fairmount and Cedar Roads in November 1947. (Jim Spangler collection.)

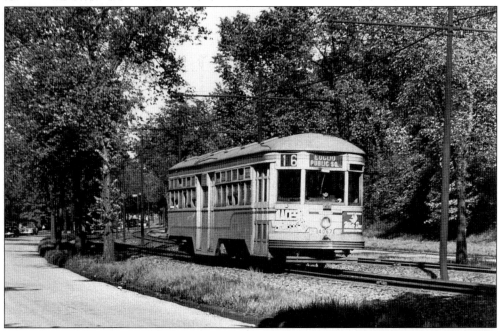

From the top of Cedar Road hill to Coventry Road, the tracks for the Mayfield streetcar line were situated in a Euclid Heights Boulevard center reservation. In 1948, CTS 4067 is westbound on Euclid Heights Boulevard on its way downtown. (J. William Vigrass photograph.)

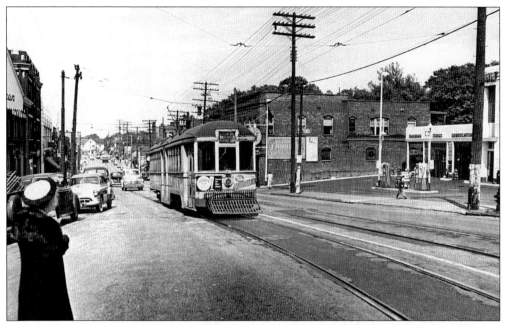

A Mayfield Road streetcar slows to pick up a passenger on Coventry Road in Cleveland Heights. The car's destination sign shows that it will travel to the Puritas loop at the end of the Lorain Avenue line. When the east and west lines were through-routed, a streetcar would travel 18 miles from one terminus to the other, by far the longest streetcar trip on the city system. (Dave Schaefer collection.)

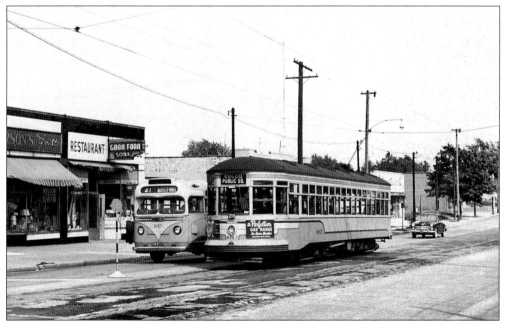

The eastern end of the Mayfield line was in a wye at Warrensville Center Road. It is September 5, 1949, the last day for streetcar service on the line. The Mayfield line, one of three to serve Cleveland Heights, was the last to give way to bus service. (Anthony F. Krisak photograph, Richard Krisak collection.)

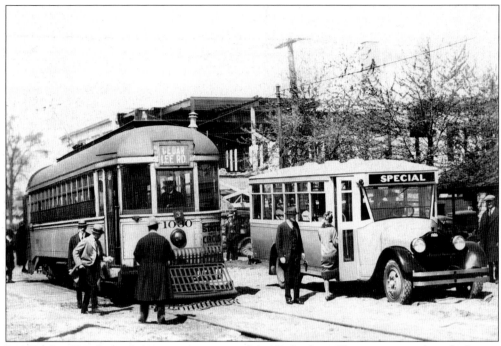

In 1926, Lee Road was the eastern terminus of the Cedar line. Here passengers board a bus to travel farther out. In 1929, the streetcar tracks were extended to Taylor Road where cars turned in a wye. (Jim Spangler collection.)

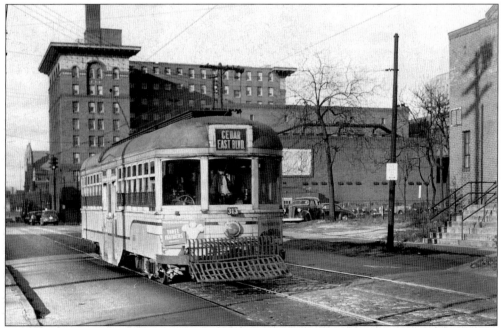

A Cedar Avenue center-entrance car is inbound, just past East 22nd Street in November 1945. It is displaying an outbound sign, identifying its destination as Cedar Glen. Streetcar service east of Cedar Glen ended in June of that year, but streetcars would remain on this inner portion of the Cedar line until June 1946. (Anthony F. Krisak photograph, Richard Krisak collection.)

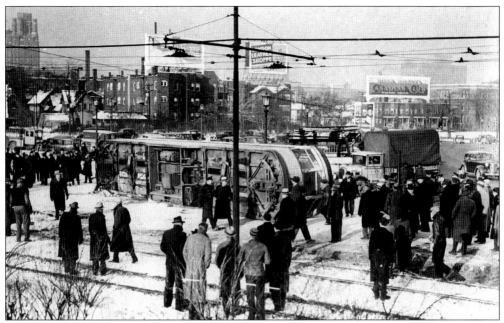

Cedar streetcars used the private right-of-way at the side of Cedar hill to reach Cleveland Heights. The hill sometimes proved a problem. On December 10, 1937, a Cedar car lost its brakes as it was descending the hill. When it hit the slight curve at the bottom of the hill, the car left the tracks. Several passengers were hurt. (*Cleveland Press* photograph, Jim Toman collection.)

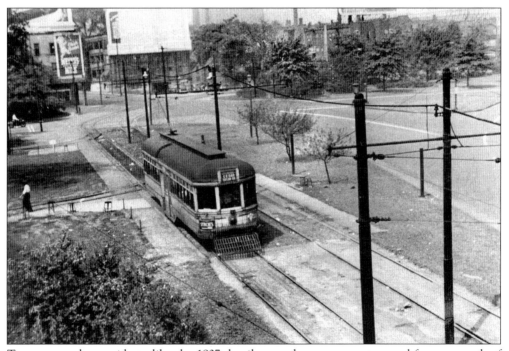

To prevent other accidents like the 1937 derailment, the curve was removed from a stretch of tracks at the bottom of Cedar Road hill. In August 1944, a center-entrance car is about to climb the hill on its trip to Taylor Road. (Jim Spangler collection.)

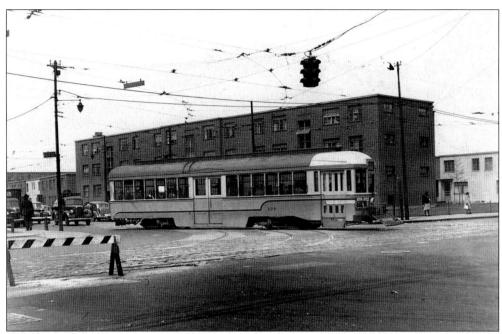

A Scovill streetcar is turning north onto East 55th Street. It will then turn east onto Quincy Avenue and continue to Woodhill Road. The Scovill line was the first car line to be converted to buses after World War II. (Jim Spangler collection.)

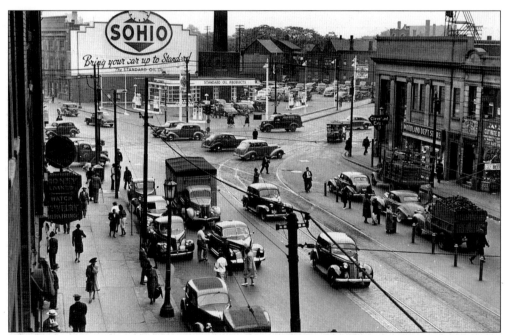

Nothing of this 1941 scene at the intersection of Woodland Avenue, Kinsman Avenue, and East 55th Street remains today. Woodland and Buckeye cars veered slightly to the left, and Kinsman cars turned towards the right. East 55th Street bisected the intersection. The corner was called the most dangerous traffic spot in the city. (*Cleveland Press* photograph, Jim Spangler collection.)

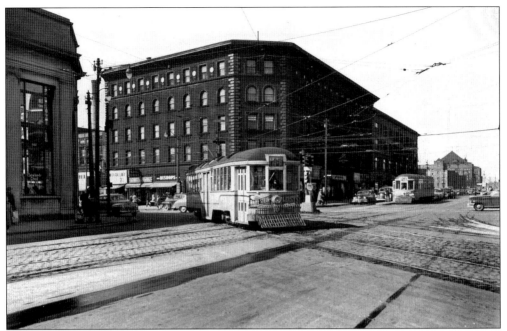

In 1950, a 100-series car in Kinsman service crosses East 55th Street. A southbound East 55th car is in the distance. Passage through the five-way intersection was guided by a traffic light mounted on a concrete stand. (Anthony F. Krisak photograph, Richard Krisak collection.)

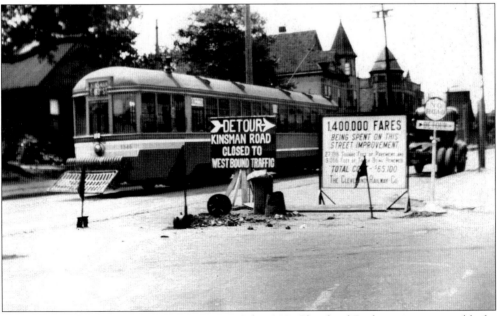

Kinsman Road was getting new pavement in July 1940. Cleveland Railway was responsible for the maintenance of the roadway from one foot on either side of the tracks. The sign is the Railway's way of letting patrons know how much money it cost to maintain its franchise to operate over Cleveland streets. (John Gaydos photograph, Jim Spangler collection.)

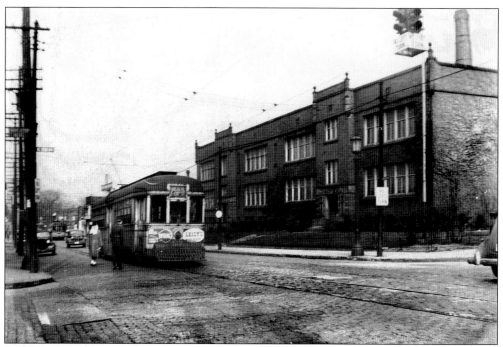

A 200-series car picks up passengers on Buckeye Road at East 116th Street. Harvey Rice School is at the left. The car wyed at East 130th Street, just shy of South Moreland Boulevard, July 1948. (Bill Cook photograph.)

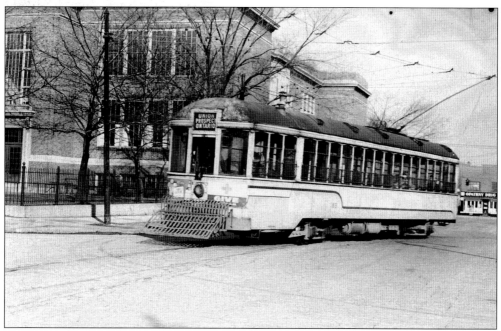

CTS 163 is leaving Corlett loop for a trip downtown. The Union cars took Prospect Avenue to East 2nd Street where they turned for their return trip. Corlett School is to the left. (Jim Toman collection.)

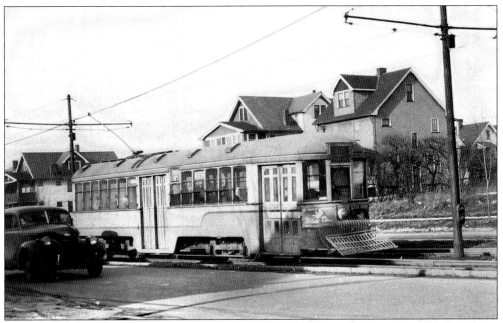

The short stretch of the Union Avenue line on East 116th Street, between Union and Corlett, operated in a center reservation. CTS 170 is not far from the end of the line at the East 130th and Corlett loop. (J. William Vigrass photograph.)

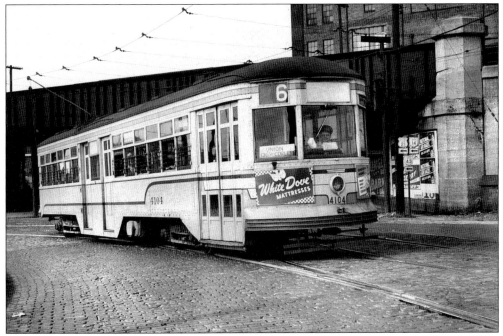

Streetcars on the Union line had less than a month to run when this photograph was taken on July 31, 1947. Here car 4104, bearing a temporary route sign, operates over the East 34th Street bridge. The building behind the railroad overpass is the A&P food warehouse. (J. William Vigrass photograph.)

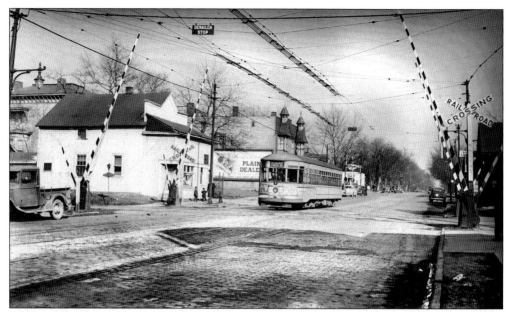

In Broadway Avenue service, CTS 4129 is on Miles Avenue on March 10, 1946. It is about to cross the Wheeling and Lake Erie Railroad tracks near East 102nd Street. The old Miles Car Barn was located in this area. (J. William Vigrass photograph.)

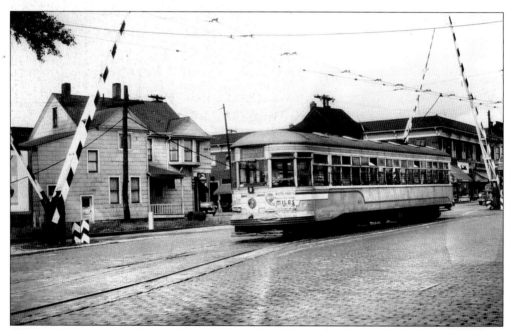

Broadway Avenue car 4111 is leaving its loop at East 131st Street and Miles Avenue. The area to the rear of the car was a popular shopping district. The streetcar tracks carefully skirted the Erie Railroad tracks to the left of the scene. (J. William Vigrass photograph.)

CTS 4130 is resting in the East 131st Street loop in 1946. After the streetcars quit, the loop was used for the replacement fleet of trackless trolleys that served the Broadway line until 1963. It is still a bus loop today. (J. William Vigrass photograph.)

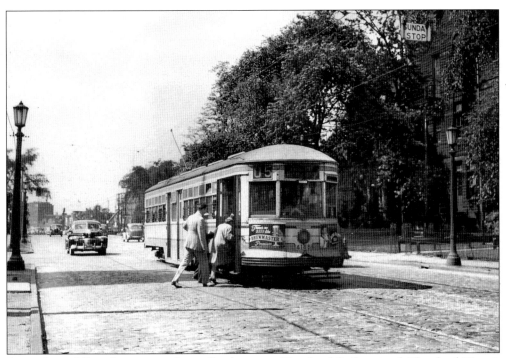

An outbound Broadway car makes a Sunday stop. Cleveland Railway and Cleveland Transit made additional stops on Sundays to accommodate passengers who were on their way to and from church services. (Brother Bernard Polinak photograph, Richard Krisak collection.)

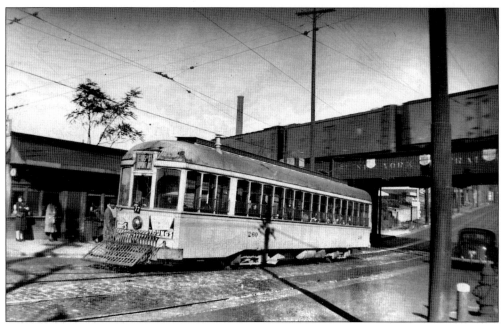

East 105th Street car 260 is on Quincy Avenue. It has just left Woodhill Road, passed under the New York Central overpass, and it will turn north on East 105th Street. (Harry Christiansen photograph, Jim Toman collection.)

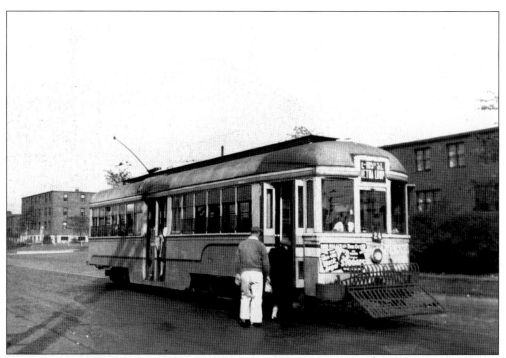

An East 105th Street car is passing the Morris Black subsidized housing development on Woodhill Road, just north of Woodland Avenue. The housing development was built on the site of the former Luna Park, 1946. (Jim Spangler collection.)

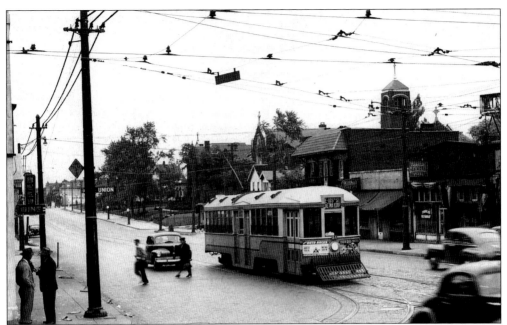

Southbound car 1337 is on East 93rd Street at Union Avenue in June 1947. The long East 105th Street line had several cutbacks. This car will only go another few blocks to the Aetna Road loop before turning back north. St. Catherine Church is in the background. (Anthony F. Krisak photograph, Richard Krisak collection.)

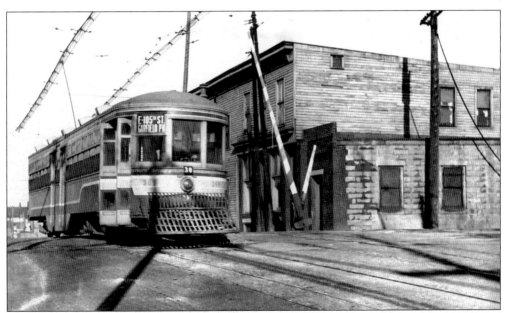

Cleveland Railway 369, on its way to Garfield Park, is crossing the Erie Railroad tracks on East 93rd Street. The conductor has left the car to release the derail switch, a safety mechanism to make operators cautious about crossing a railroad line. The wire guards were another safety feature, making sure the car would still receive power even if the vibration of the rail crossing might make the trolley wheel jump the wire. (Arnold Bushnell photograph, Jim Spangler collection.)

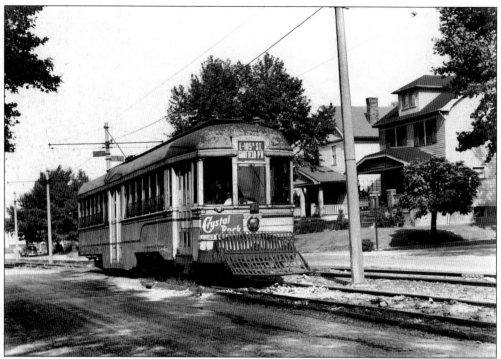

On September 21, 1947, CTS 214 is gliding along the private right-of-way on Garfield Park Boulevard near Horton Avenue on its way to the southern terminus of the long East 105th Street line. When CTS converted most of the East 105th Street line to trackless trolley operation in 1948, this southern portion was served by a bus shuttle. (Jim Spangler collection.)

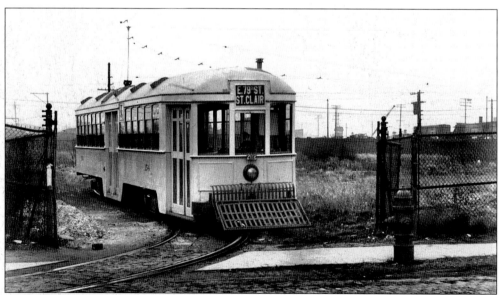

Cleveland Railway 154 rests in Bessemer loop, at the southern end of the East 79th Street line. The loop was located in a large acreage that Cleveland Railway had purchased for the site of another operating station. The station was not built. (Jim Spangler collection.)

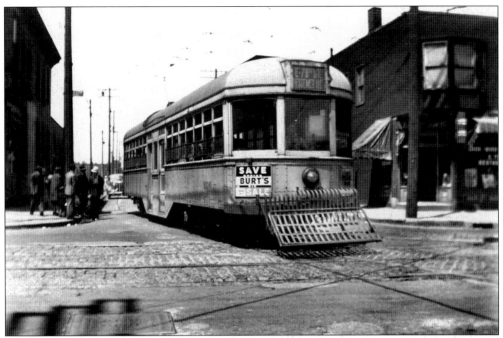

Center-entrance car 1110 is crossing Woodland Avenue on the East 79th Street line. The Transfer Lunch restaurant at the left end of the picture was a popular lunch stop for workers in the many factories that dotted the area in 1940. (Jim Spangler collection.)

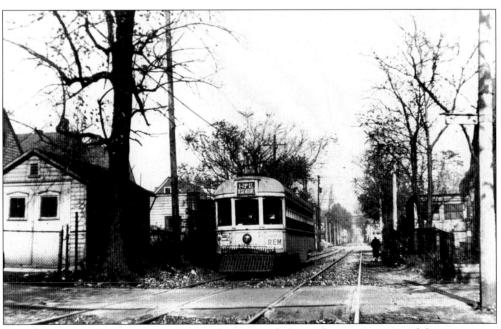

During the years of streetcar service on the East 79th Street line, some parts of the street were not open to automobile traffic. The private right-of-way portions of the route were paved over for autos after the streetcar line was converted to buses. This scene is from the last day of streetcar service on November 15, 1940. (Jim Spangler collection.)

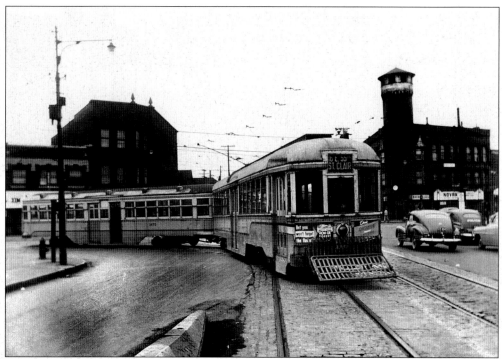

A 200-series car pulls a trailer onto East 55th Street from St. Clair. The motorman forgot to change the destination sign. This southbound car was headed to War Avenue and East 71st Street in 1950. (Roy Bruce photograph.)

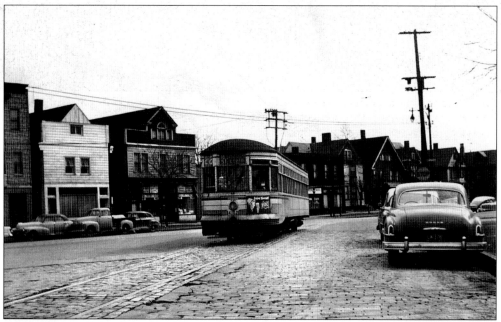

CTS 4102 has turned onto Marquette Avenue, at the northern end of the East 55th Street line. The car will turn onto St. Clair Avenue and then back to East 55th for its southbound trip. This is the last day of streetcar service on the line, March 7, 1953. (Jim Spangler photograph.)

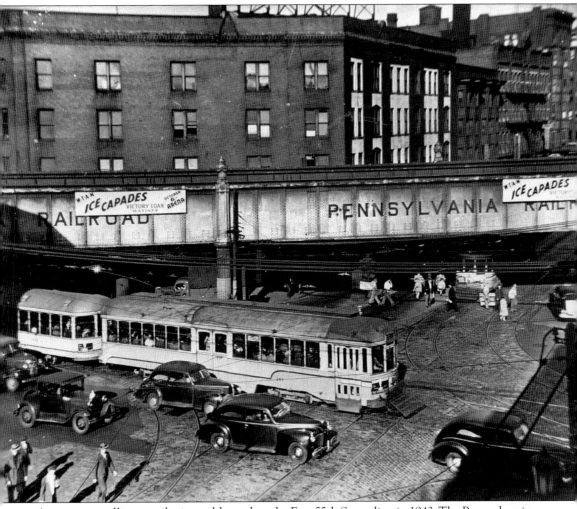

A motor car pulling a trailer is southbound on the East 55th Street line in 1943. The Pennsylvania Railroad overpass crosses the intersection. A Euclid Avenue car peaks out from under the bridge. (*Cleveland Press* photograph, Jim Spangler collection.)

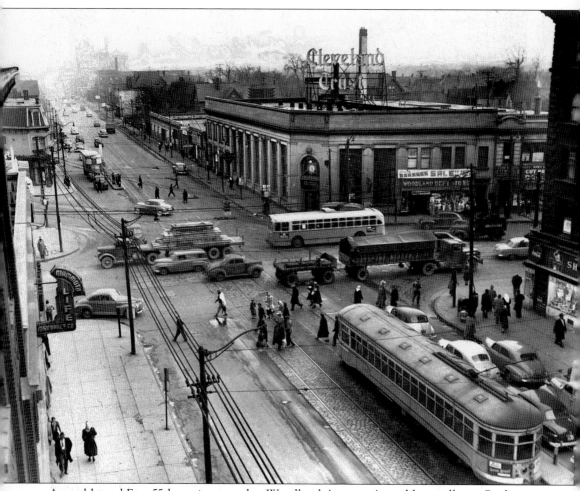

A southbound East 55th car is stopped at Woodland Avenue. A trackless trolley in Buckeye or Woodland service is eastbound. A branch of the old Cleveland Trust bank is on the southwest corner. A hotel occupies the northeast corner. It is 1951, and with the Kinsman Avenue line no longer streetcar operated, a new overhanging traffic signal is at the center of the complex intersection. (Robert Runyon photograph, Bruce Young collection.)

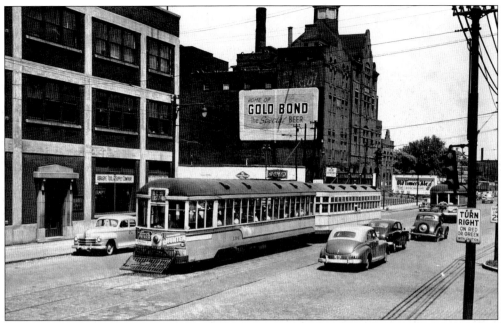

CTS 1304 pulls a trailer south on East 55th Street just north of the bridge over the Nickel Plate Railroad tracks. The Sandusky Brewing company, home of Gold Bond and other popular beers, is at the rear center of the scene. (Anthony F. Krisak photograph, Richard Krisak collection.)

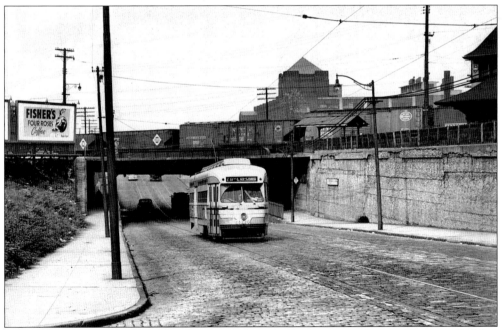

PCC cars were a common site on the East 55th Street line in its final years. Here car 4220 has passed under the Erie Railroad overpass. The building in the distance at the left was the Kroger Foods warehouse. (Anthony F. Krisak photograph, Richard Krisak collection.)

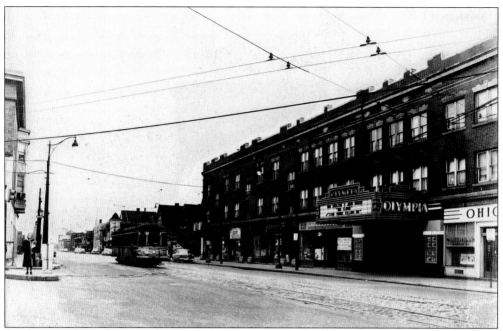

An East 55th Street car is passing the Olympia Theater just north of Broadway Avenue in 1952. Just past Broadway, the line would take Hamm Avenue to East 49th Street. Some cars ended there at Chard loop. Others traveled onto a loop at the Harvard Yards, and still others traveled east to East 71st Street. (Robert Runyon photograph, Bruce Young collection.)

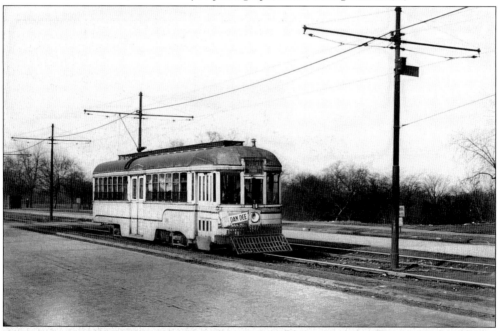

Car 299 is on the Washington Park branch of the East 55th Street line. The car will continue to the Harvard Shops, where it will wye for a return trip. This branch of the line ceased service in 1948 to accommodate a bridge-replacement project. After that, streetcars headed for the shops had to take East 71st Street to Harvard. (J. William Vigrass photograph.)

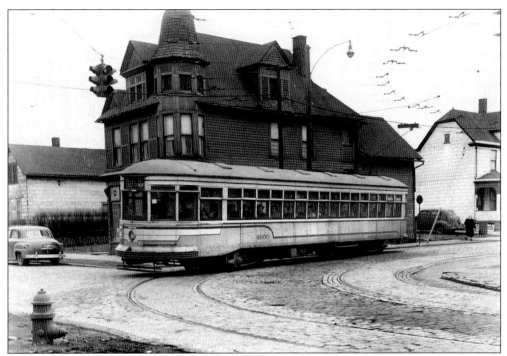

It is Saturday, March 7, 1953, the last day of streetcar service on the East 55th Street line. Car 4000, the premier car in the series, is turning onto East 49th Street from Hamm Avenue. (Jim Spangler photograph.)

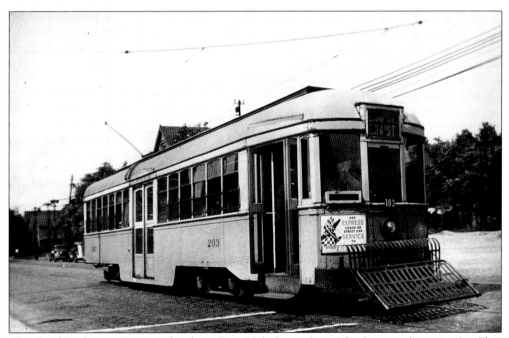

Cleveland Railway 203 is on the short East 30th Street line. The line ran between St. Clair Avenue and Croton Avenue. The lightly patronized line was converted to buses in 1940. The car is southbound at Superior Avenue. (Jim Spangler collection.)

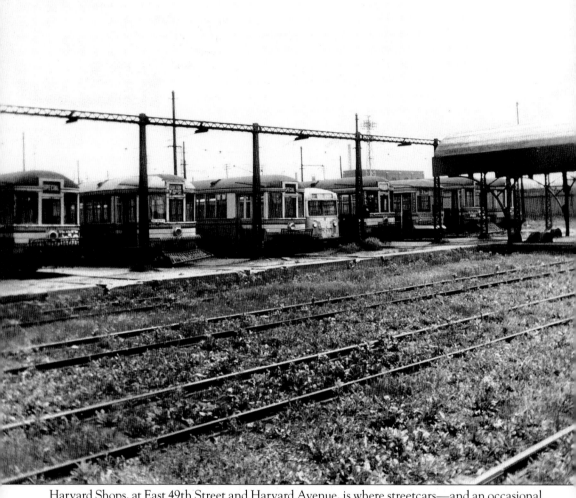

Harvard Shops, at East 49th Street and Harvard Avenue, is where streetcars—and an occasional bus—were repaired and also where they were scrapped. The cars are lined up in readiness for a trip on the transfer table, at the left, in 1951. (Roy Bruce photograph.)

Six

SPECIAL EVENTS

As Clevelanders became aware that the streetcar era in their city was nearing its end, a wave of nostalgia set in. This took various forms. One favored approach was to assemble a group and charter a streetcar to travel over the remaining system. Some events were sponsored by city councilmen and consisted of small parades to mark the end of streetcar service on a given line. The most celebrated event was the Parade of Progress down Euclid Avenue, the city's main street. The last event was a Farewell to Streetcars, during which riders were given a free ride over a part of the Madison Avenue streetcar line, the last streetcar line in the city.

The Parade of Progress was held on April 27, 1952, to mark the end of streetcar service on Euclid Avenue. Hundreds of vehicles, from old automobiles, to buses, to several generations of work and passenger streetcars, paraded down the avenue from East 24th Street to Public Square. Police estimated the throng of people that lined the street numbered over 300,000. At no time, before or since, has the size of that crowd been surpassed for any event in the city.

The Farewell to Streetcars took place on January 24, 1954. A crowd of about 10,000 gathered to take one final ride on a Cleveland streetcar. Some waited in line for hours in the bitterly cold weather before they could finally step onto a warm car for the last time.

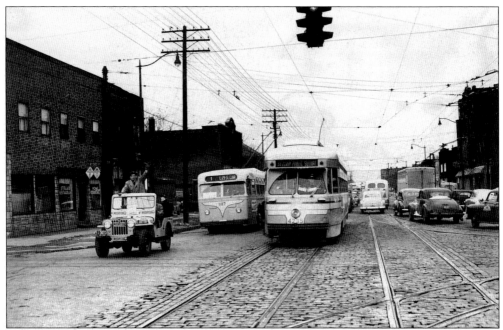

A mini-parade marked the end of streetcar service on St. Clair Avenue on November 3, 1951. A replacement St. Louis Car Company trackless trolley trails PCC 4235. A city official is taking credit for the improvement. (Anthony F. Krisak photograph, Richard Krisak collection.)

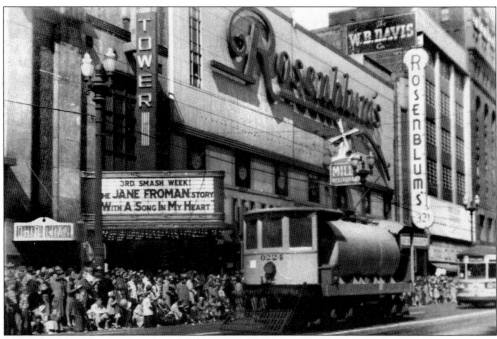

Sprinkler work car 0224 was one of the many trolleys to participate in the Parade for Progress on Euclid Avenue on April 27, 1952. The car is near Public Square, and the only song in most Clevelanders' hearts that day was a sad one. (Al Kleinsmith photograph.)

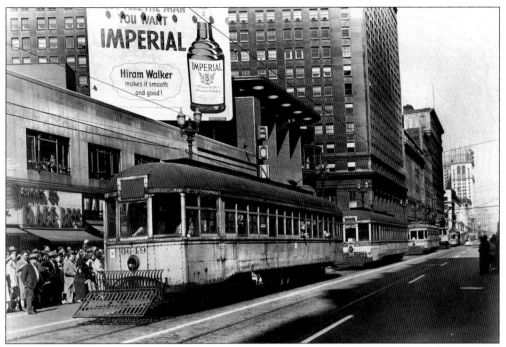

A steady procession of Cleveland Transit System work equipment gave the Parade of Progress' 300,000-person crowd a good sense of how rail-car design had changed over the years. The scene is on Euclid Avenue between East 9th and East 6th Streets. (Robert Runyon photograph.)

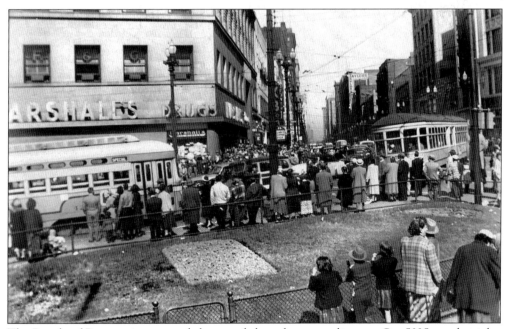

The Parade of Progress is over, and the crowds have begun to disperse. Car 5025, on the right, will make one trip back to Windermere before heading to Harvard Yard. PCC 4215 will report to East 55th Street Station. (Bill Cook photograph.)

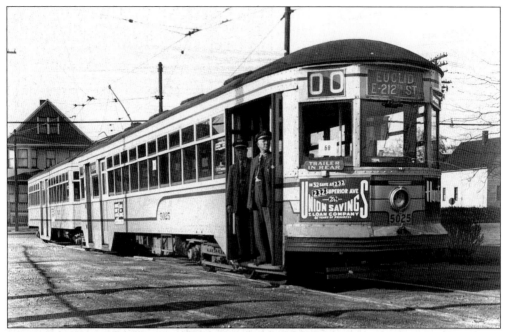

The crew of CTS articulated-car 5025 has completed its final run. It was the last of the 5000-series cars to operate. Here the crew poses at the East 55th Street Station on April 27, 1952. (Jim Spangler photograph.)

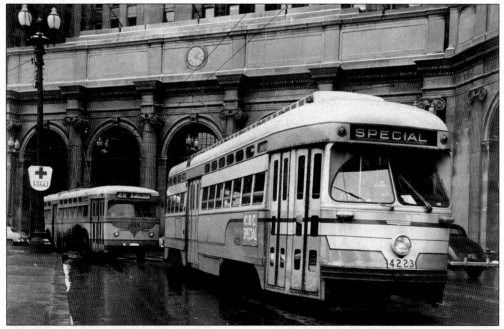

After CTS decided to end the city's streetcar operations, the city's PCC cars were sold to the Toronto Transit Commission and shipped north during 1952 and 1953. Before it was too late, rail fans chartered car 4223, a Pullman-Standard model, on March 8, 1953, for a tour of the city's remaining active tracks. It pauses in front of the main entrance to Cleveland's Terminal Tower. Behind is Lorain Avenue trackless trolley 1024. (Jim Spangler photograph.)

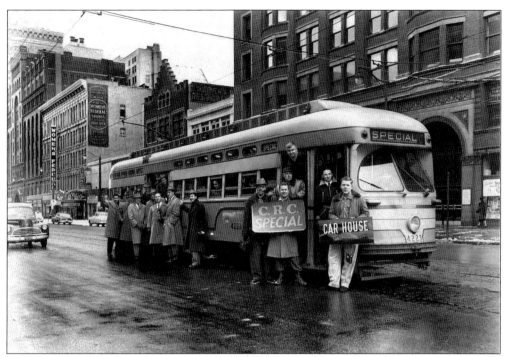

Car 4223 carried a full load of rail fans on March 8, 1953. One fan is holding the Cleveland Railway Club banner. Another holds a destination roller indicating the final stop that this charter trip will make. (Robert Runyon photograph, Jim Spangler collection.)

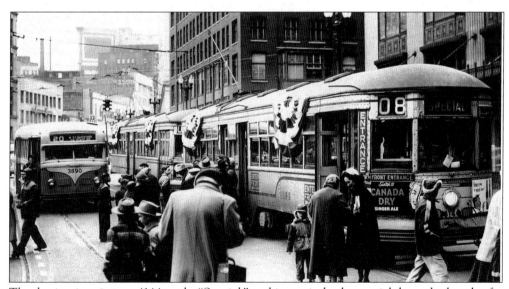

The destination sign on 4144 reads, "Special," and it was indeed a special day—the last day for streetcars in Cleveland—January 24, 1954. A crowd estimated to number 10,000 gathered in Public Square to take a final streetcar ride. (J. William Vagrass photograph.)

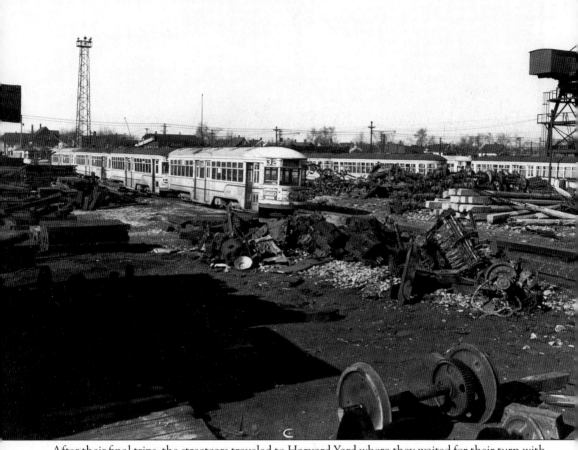

After their final trips, the streetcars traveled to Harvard Yard where they waited for their turn with the scrapper's torch. Very few Cleveland streetcars have survived. The few 1200-series survivors owe their preservation to having spent some time on the Shaker Heights Rapid Transit, and the few PCC cars to having been sold to the Toronto Transit Commission. (Bruce Young collection.)

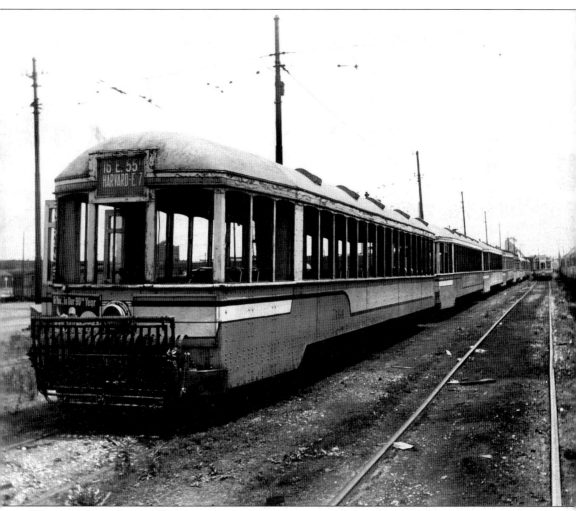

The scrap line at Harvard Yard was the final destination for almost all of the Cleveland streetcars. The cars' brass fittings have been removed for salvage, and CTS 164 is next in line for the torch. (Roy Bruce photograph.)

BIBLIOGRAPHY

Central Electric Railfans' Association. *Electric Railways of Northeastern Ohio.* Chicago: CERA, 1965.

Christiansen, H. *Trolley Trails Through Greater Cleveland and Northern Ohio: From the Beginning to 1910. (V. 2).* Cleveland: Western Reserve Historical Society, 1975.

Christiansen, H. *Trolley Trails Through Greater Cleveland and Northern Ohio: From 1910 to Today. (V. 3).* Cleveland: Western Reserve Historical Society, 1975.

Hays, B. S. and J. A. Toman. *Cleveland Transit Through the Years.* Cleveland: Cleveland Landmarks Press, 1999.

Morse, K. S. *A History of Cleveland Streetcars from the Time of Electrification.* Baltimore: Privately published, 1955.

Morse, K. S. *Cleveland Streetcars, Part II.* Baltimore: Privately published, 1964.

Toman, J. A. *Cleveland.* In *Motor Coach Age,* July-September 1999, 3–42.

Toman, J. A. and Hays, B. S. (1996). *Cleveland Transit Vehicles: Equipment and Technology.* Kent, OH: Kent State University Press.

Toman, J. A., B. E. Young, J. R. Spangler, and B. S. Hays. *When Cleveland Had a Subway.* Cleveland: Cleveland Landmarks Press, 1999.

Toman, J. A. and B. S. Hays. *Horse Trails to Regional Rails: The Story of Public Transit in Greater Cleveland.* Kent, OH: Kent State University Press, 1996.

Westinghouse Electric Manufacturing Company. *The Cleveland Railway: Its Operation and Maintenance.* East Pittsburgh, PA: Westinghouse, 1924.